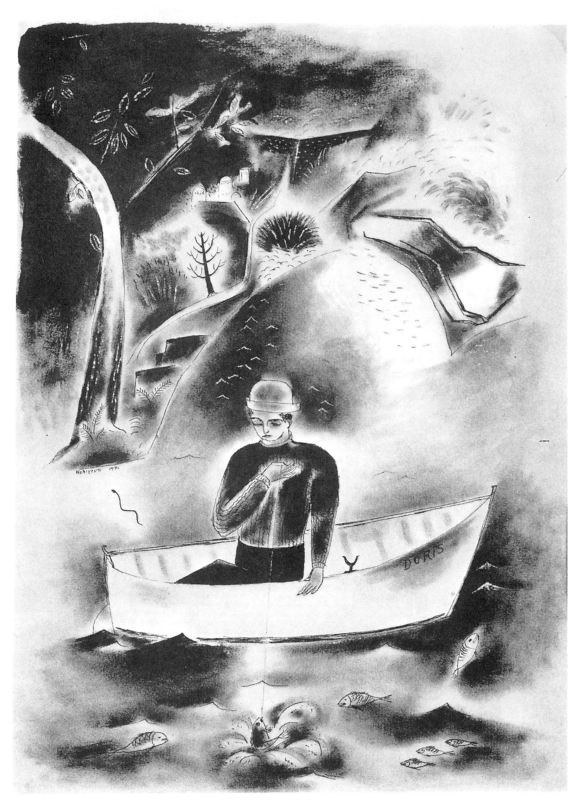

Yasuo Kuniyoshi. *Fisherman*.

American Drawings *and* Prints

From Benjamin West to Edward Hopper

Edited by
EVAN BATES

Dover Publications, Inc.
Mineola, New York

Copyright

Copyright © 2007 by Dover Publications, Inc.
All rights reserved.

Bibliographical Note

American Drawings and Prints: From Benjamin West to Edward Hopper is a
new work, first published by Dover Publications, Inc., in 2007.

Library of Congress Cataloging-in-Publication Data

American drawings and prints : from Benjamin West to Edward Hopper / edited
by Evan Bates.
 p. cm.
 ISBN 0-486-44834-7 (pbk.)
 1. Drawing, American—19th century. 2. Drawing, American—20th century.
3. Prints, American—19th century. 4. Prints, American—20th century.
I. Bates, Evan.
NC107.A64 2007
741.973—dc22
 2006052119

Manufactured in the United States of America
Dover Publications, Inc., 31 East 2nd Street, Mineola, N.Y. 11501

Introduction

This volume presents *works on paper* by many of the country's most significant artists from colonial times to the mid-twentieth century. Featured are pieces by American-born citizens working at home and abroad, as well as images by foreign-born artists who created much of their best work here. The collection's organizing principle is primarily aesthetic, and its goal is to exhibit to the viewer a wide variety of compelling images whose creators they may then be inclined to investigate further on their own.

The dominant aesthetic and spirit behind *American Drawings and Prints* could fairly be called *American Scene*, an art-historical term derived from an early-twentieth-century Henry James travelogue of the same name. In the book, James relates his return to America after an absence of nearly a quarter-century, reveling in his ability to look at the country from a new perspective. As an art term, American Scene has somewhat loose boundaries, but generally it describes the attempt by American artists in the second and third decades of the twentieth century to find vitality and significance in native and everyday subjects. Their primarily realist art was in contrast to the more dominant and abstract modernist tendencies imported from Europe and elsewhere, and came to be regarded as one of the most singularly American modes of representation in art history. The term is probably most often applied to the Regionalists (Grant Wood, Thomas Hart Benton, John Steuart Curry) who, in the present book, define the section "Landscapes and the Country." Their urban predecessors, The Eight, or Ashcan School, are prevalent in the opening section, "Images of the City."

However, *American Drawings and Prints* exhibits a much wider sampling of American art than American Scene realism, such as works that were made prior to the twentieth century as well as those outside of the fine-art tradition. Since it presents more traditional genres, the section "Portraits and Figures" reaches back furthest into history, beginning with Benjamin West, the first American to gain significant standing in the international art world. West is represented by multiple works, as are other such key figures as Thomas Eakins and James Abbott McNeill Whistler. The section is organized by type only, starting with heads and continuing through pairs to female and, finally, to male figures; eras and pictorial methods are mixed throughout.

Whether because of their origins—anonymous, religious, or commercial—or their extraordinary subjects, the images in the final section, "Folk and Fantastic Art," seemed to demand a heading of their own. The untrained artists at the beginning have developed aesthetics as powerful as many of their fine-art brethren (see, for example, the Pennsylvania-German horse on page 89). Given their subjects, the remainder of the images here can't be tethered to a time or place, but many are as uniquely American as their more realist counterparts.

List of Plates

Portraits and Figures

Landscapes and the Country

Folk and Fantastic Art

Images of the City

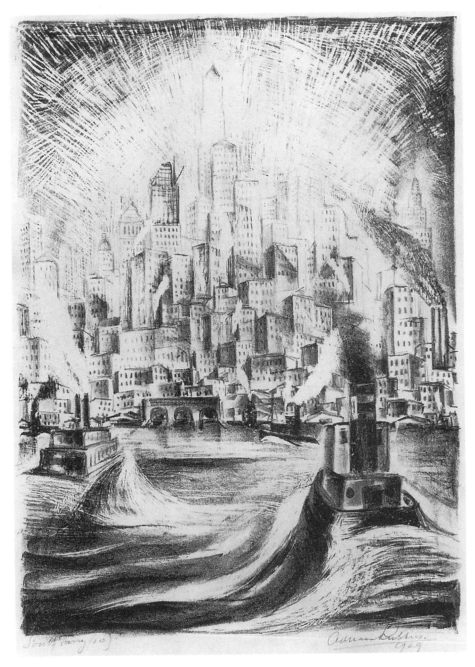

Adriaan Lubbers. *South Ferry.*

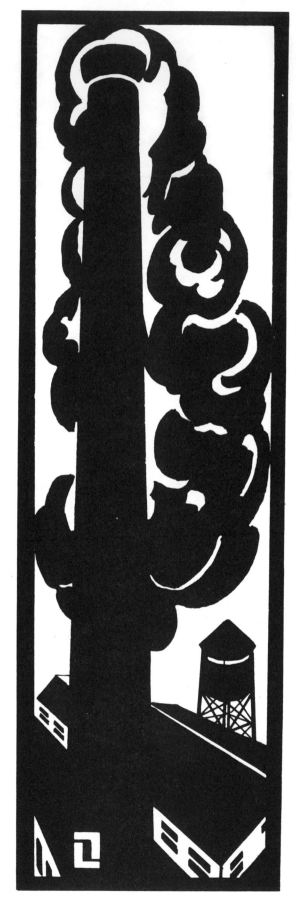

Louis Lozowick. *Smoke Stack*.

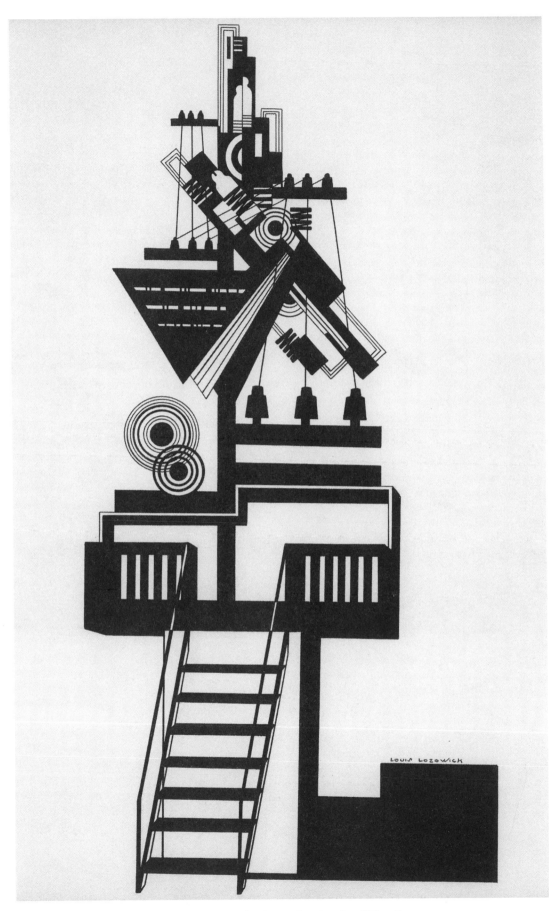

Louis Lozowick. *Stage Setting for "Gas."*

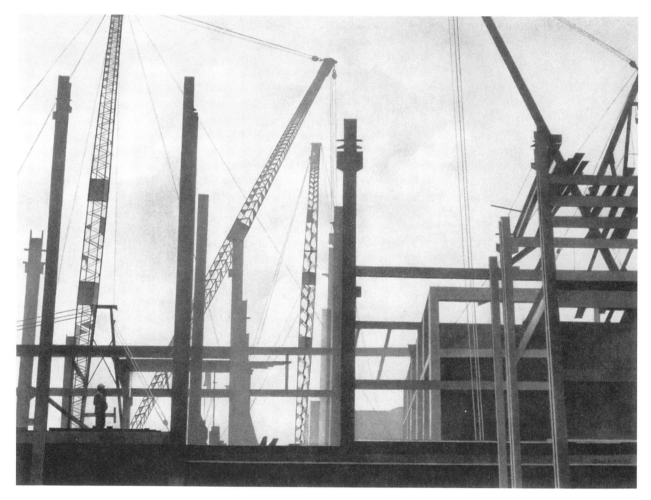

Charles Sheeler. *Totems in Steel*.

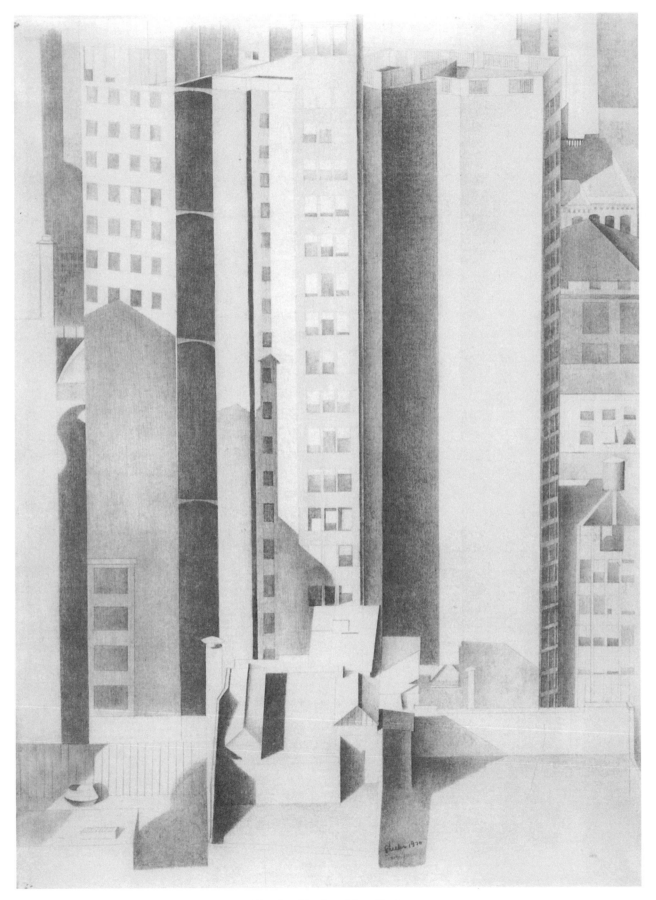

Charles Sheeler. *New York*.

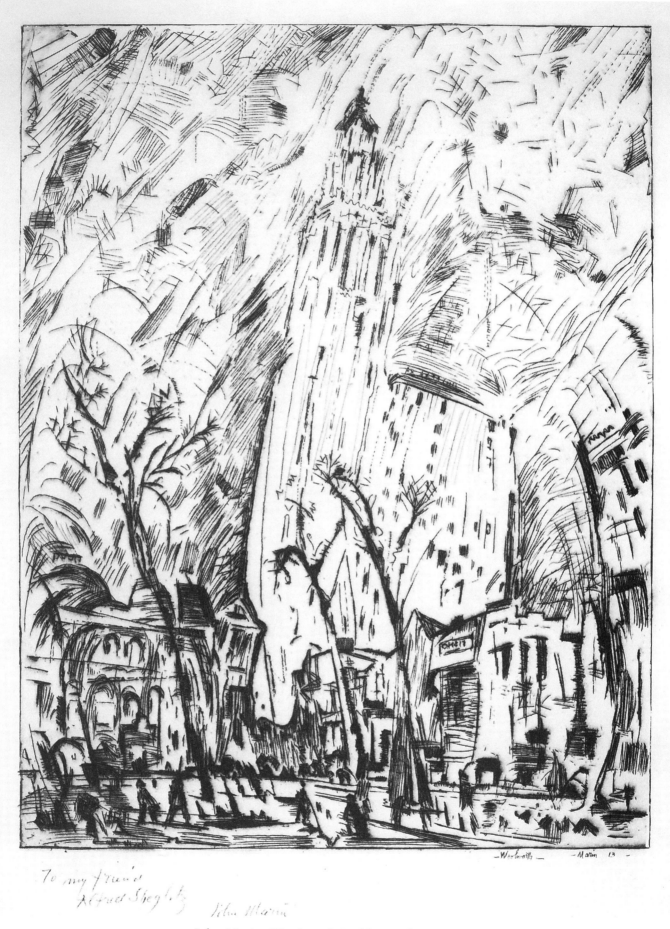

To my friend
Alfred Stieglitz

John Marin

John Marin. *Woolworth Building (The Dance).*

8

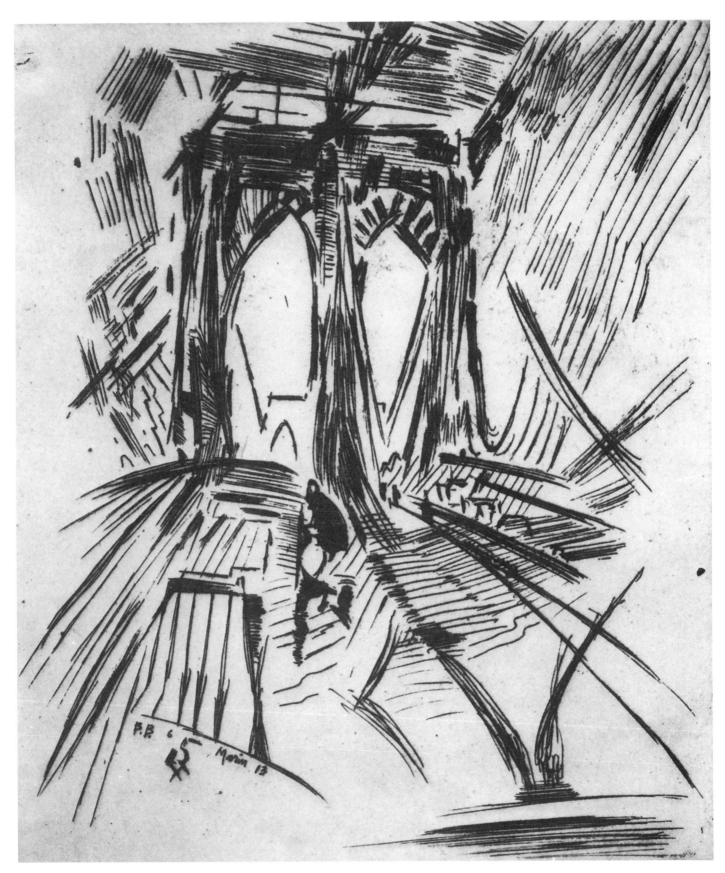

John Marin. *Brooklyn Bridge.*

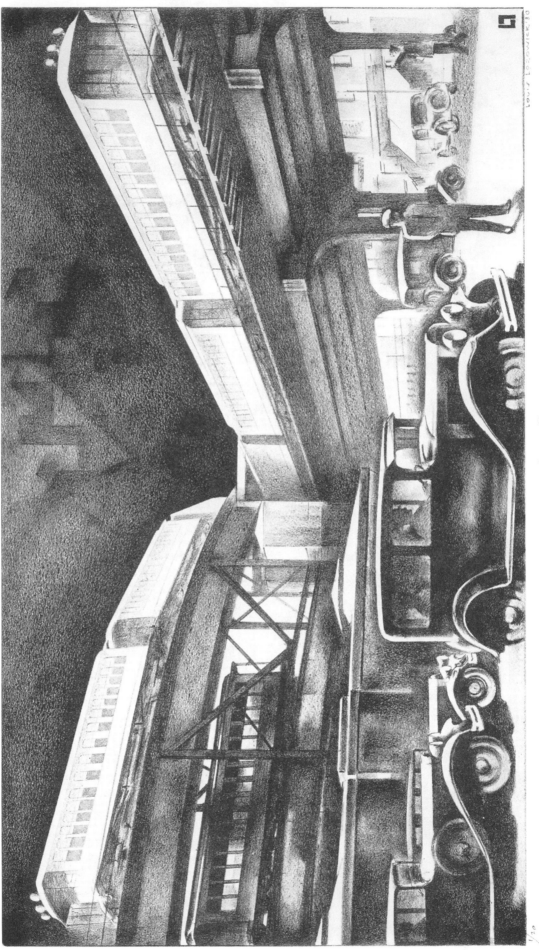

Louis Lozowick. *Traffic.*

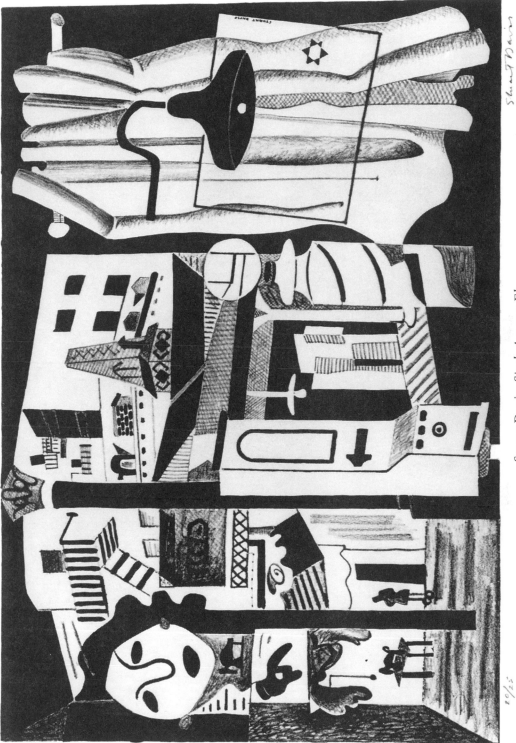

Stuart Davis. *Sixth Avenue El.*

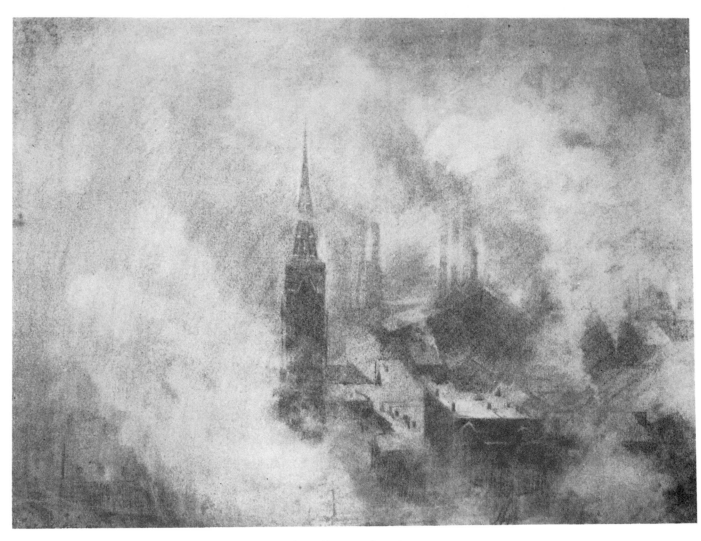

Joseph Stella. *Pittsburgh Winter.*

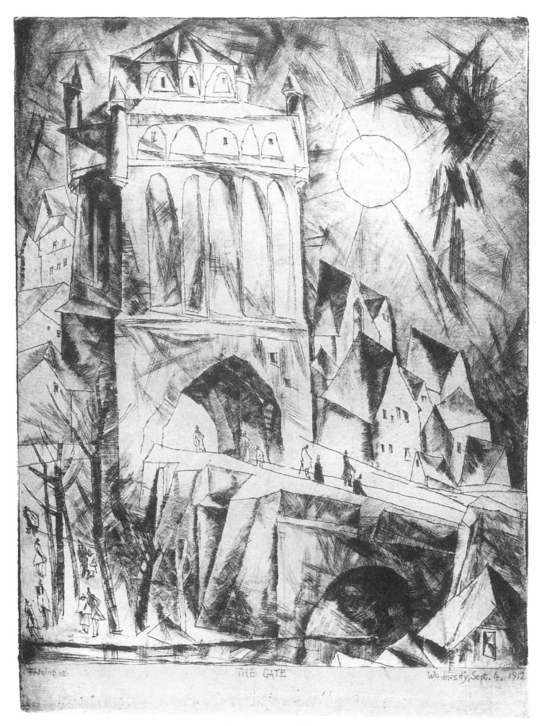

Lyonel Feininger. *The Gate.*

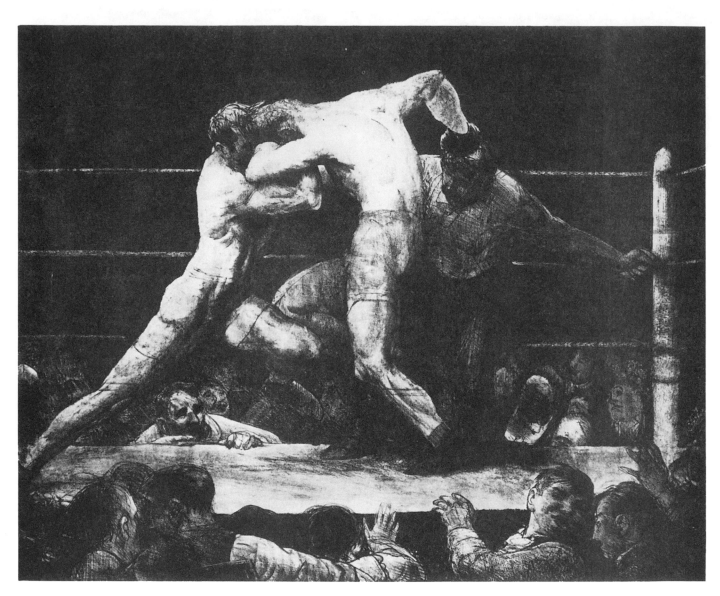

George Bellows. *Stag at Sharkey's.*

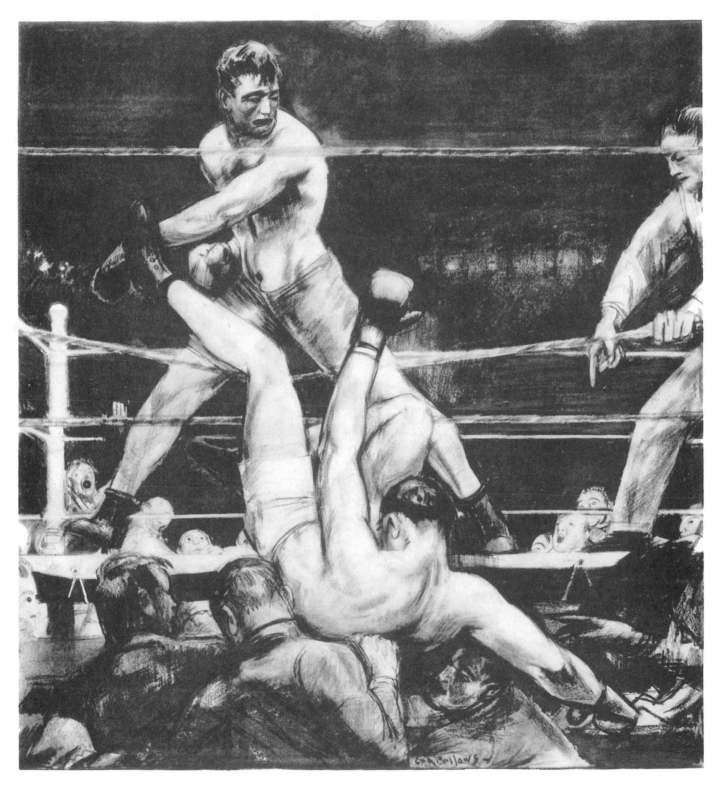

George Bellows. *Dempsey Through the Ropes.*

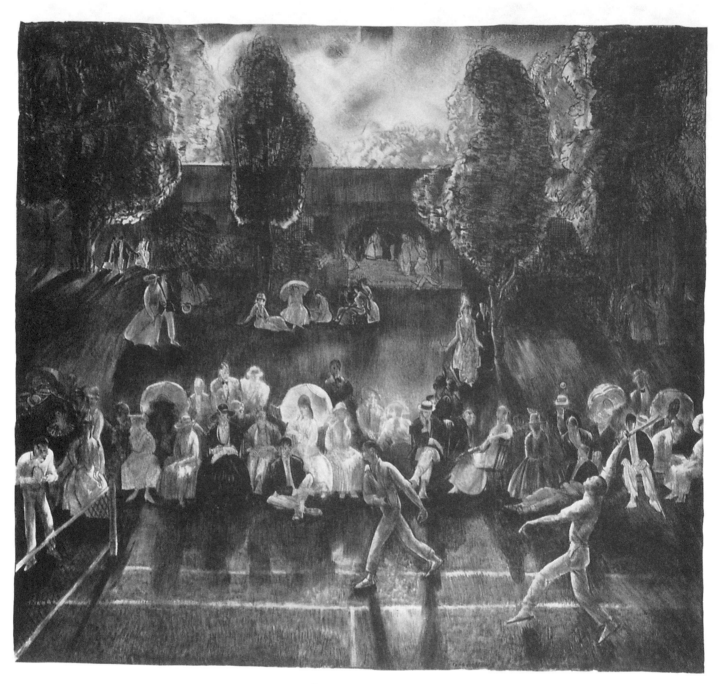

George Bellows. *Tennis Tournament.*

16

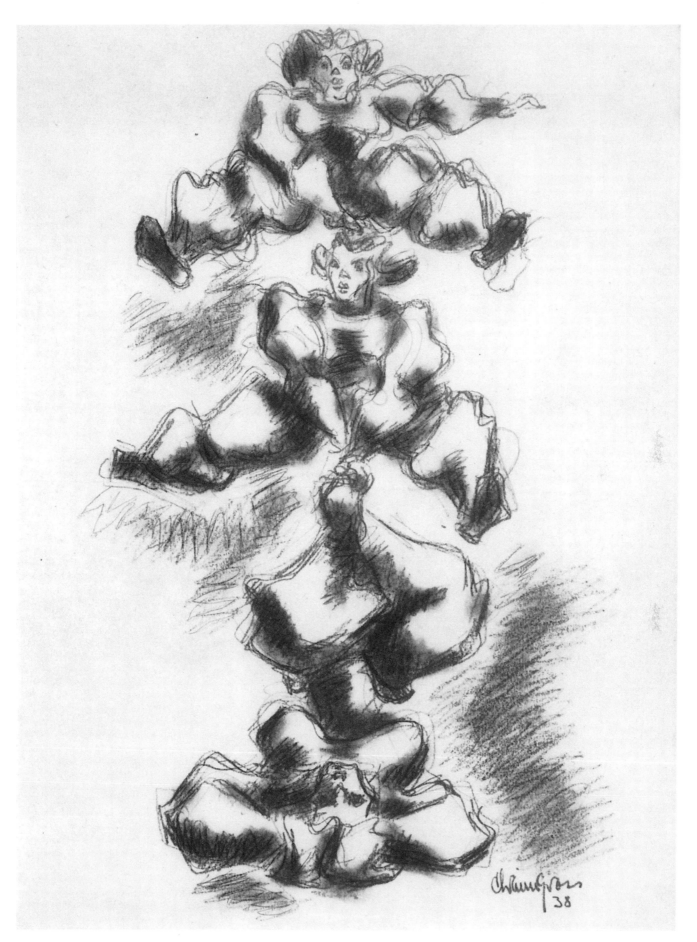

Chaim Gross. *Acrobats.*

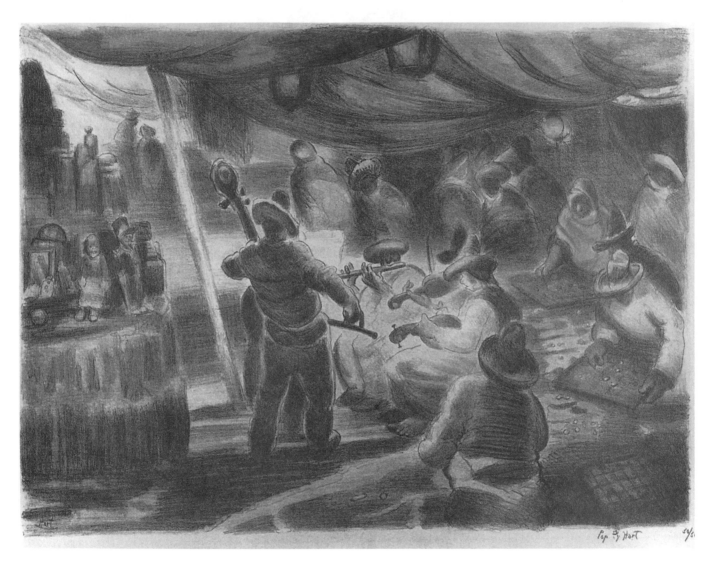

George Overbury "Pop" Hart. *Mexican Orchestra.*

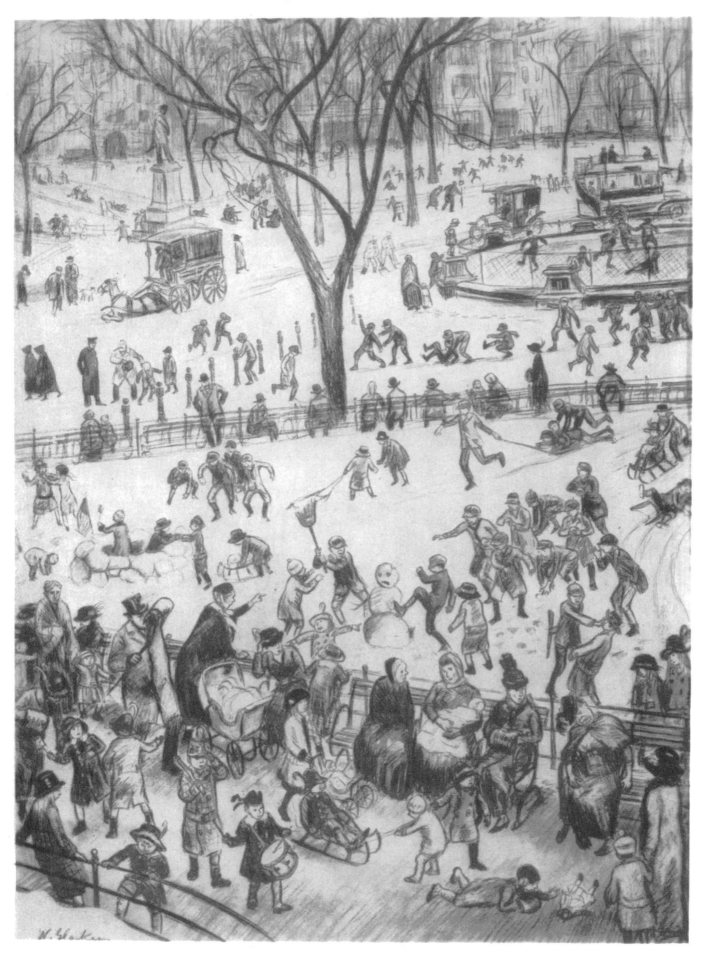

William J. Glackens. *Washington Square.*

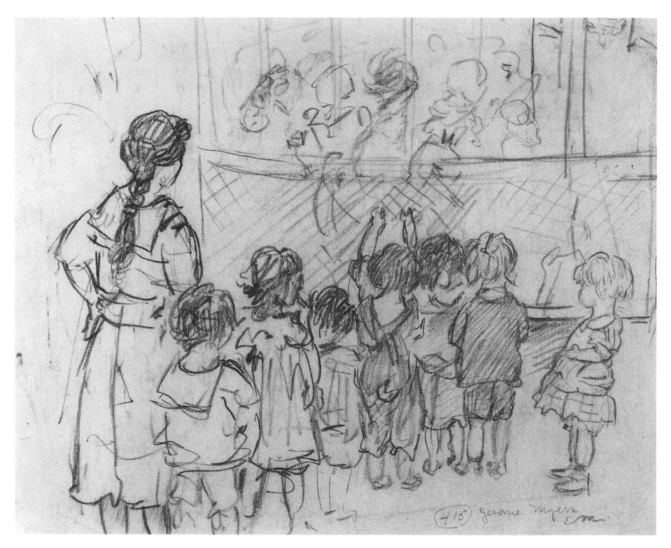

Jerome Myers. *Carousel (Merry-Go-Round).*

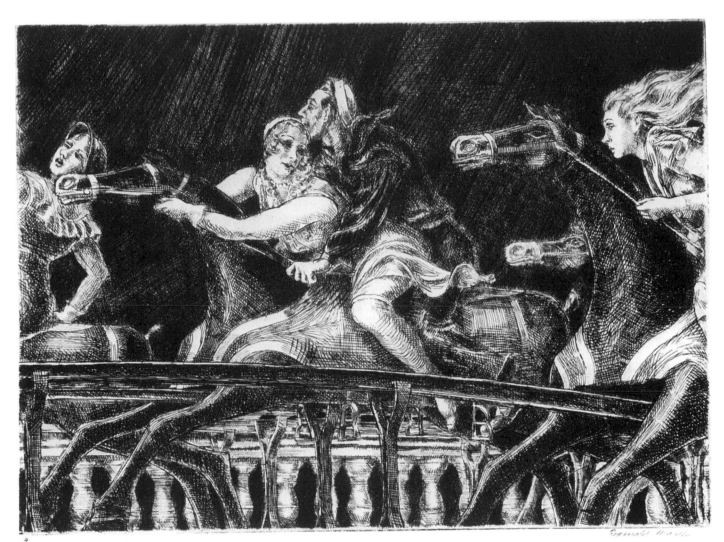

Reginald Marsh. *Steeplechase.*

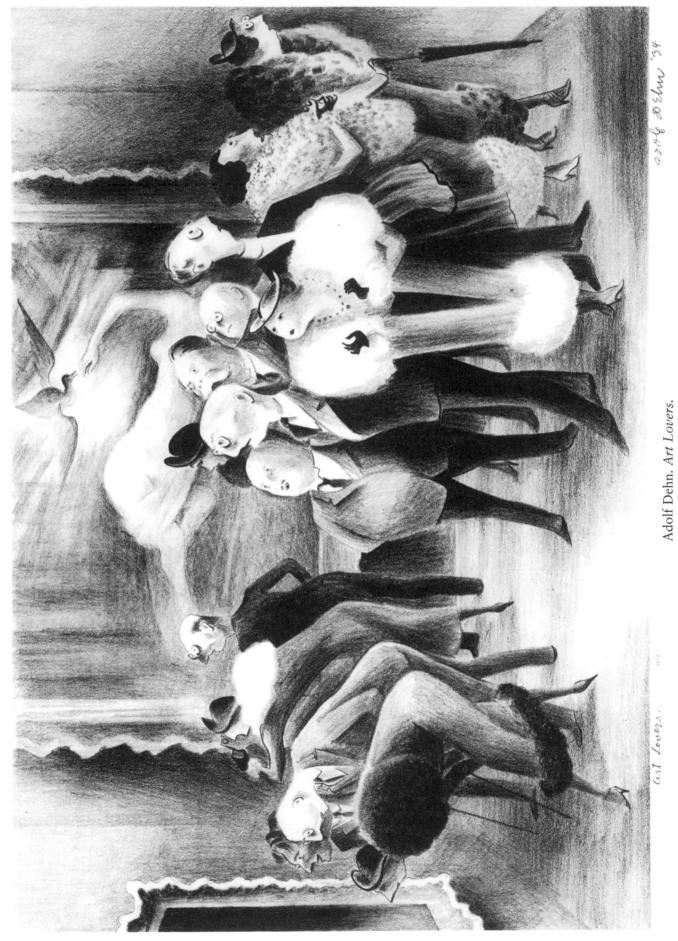

Adolf Dehn. *Art Lovers.*

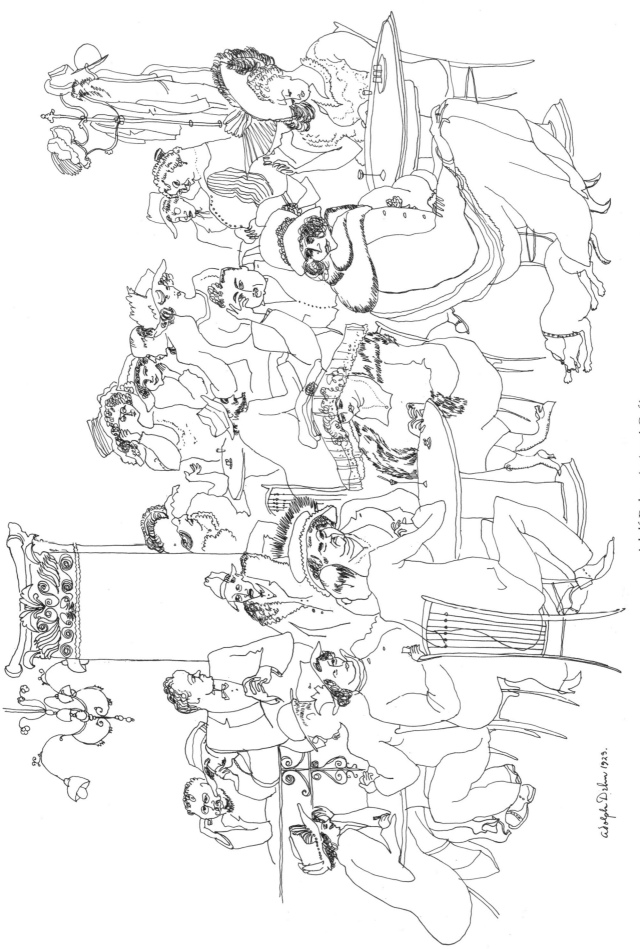

Adolf Dehn. *Artistes' Café.*

23

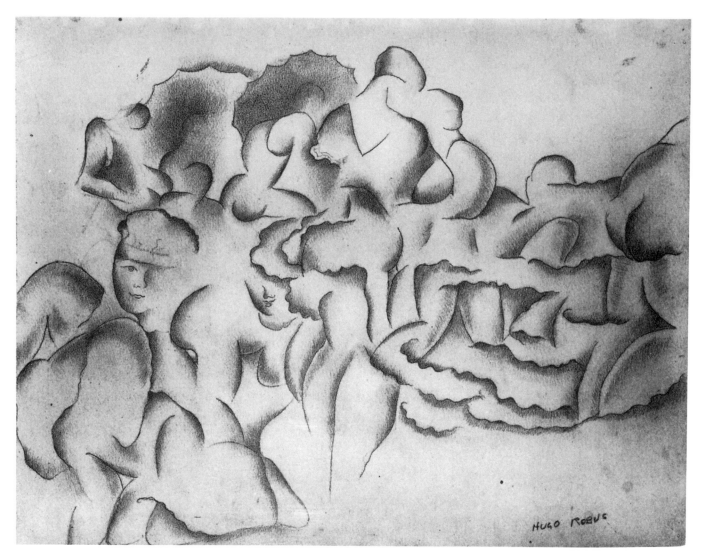

Hugo Robus. *Beach Scene.*

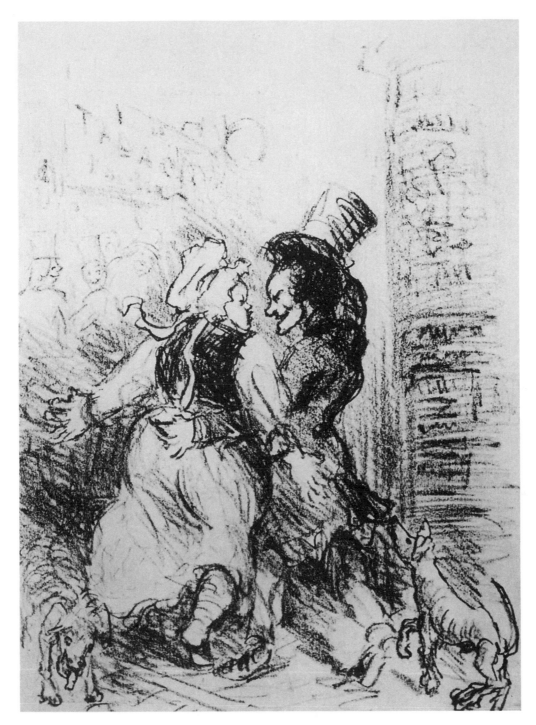

Robert Henri. *La Vie Bohème.*

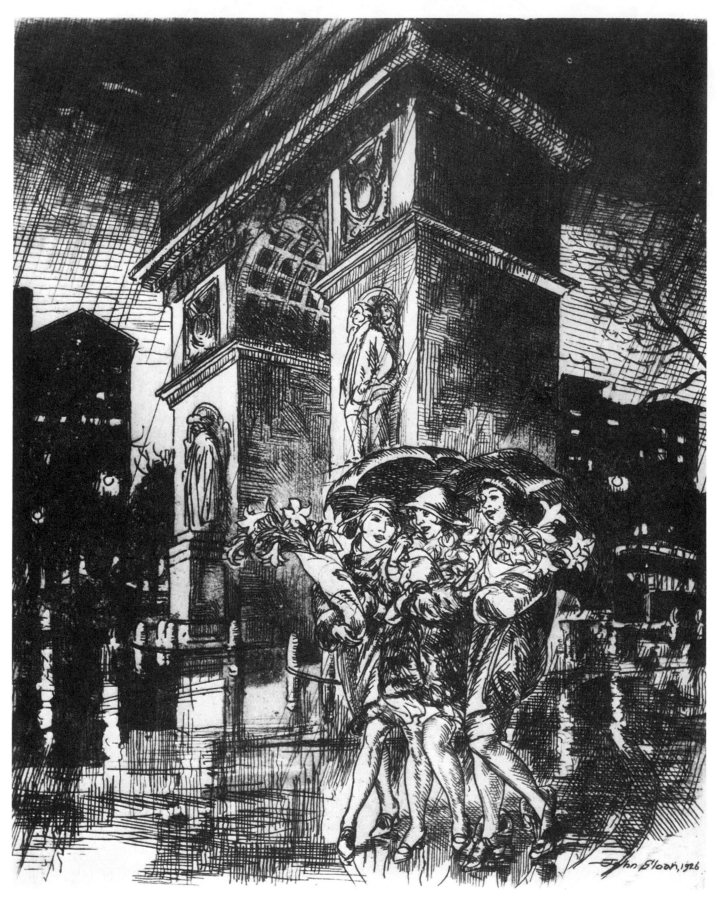

John Sloan. *Easter Eve, Washington Square.*

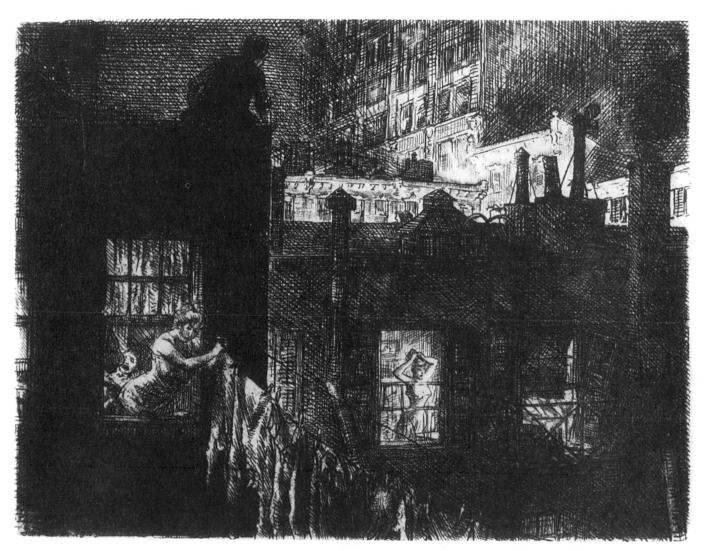

John Sloan. *Night Windows.*

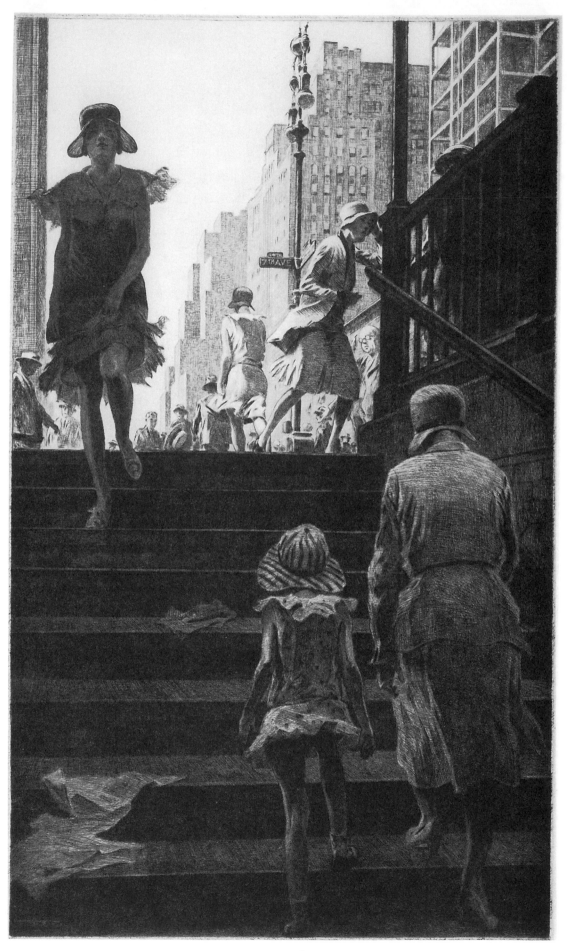

Martin Lewis. *Subway Steps*.

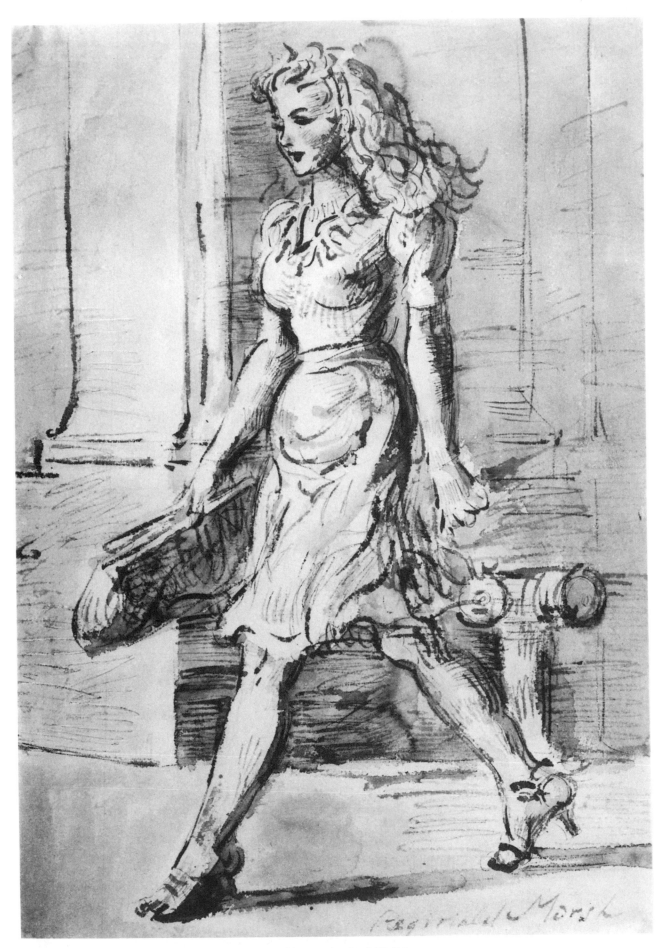

Reginald Marsh. *Girl Walking*.

29

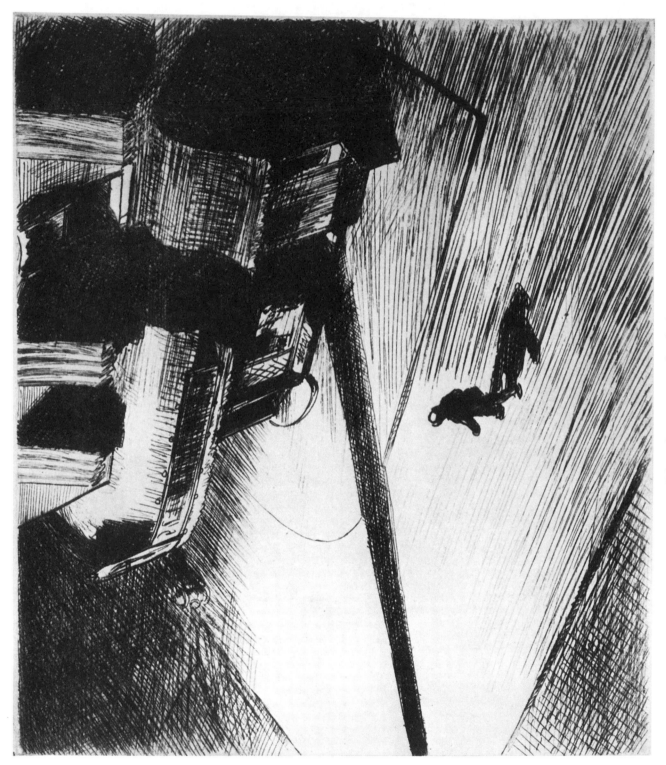

Edward Hopper. *Night Shadows.*

Edward Hopper. *Night in the Park.*

Portraits and Figures

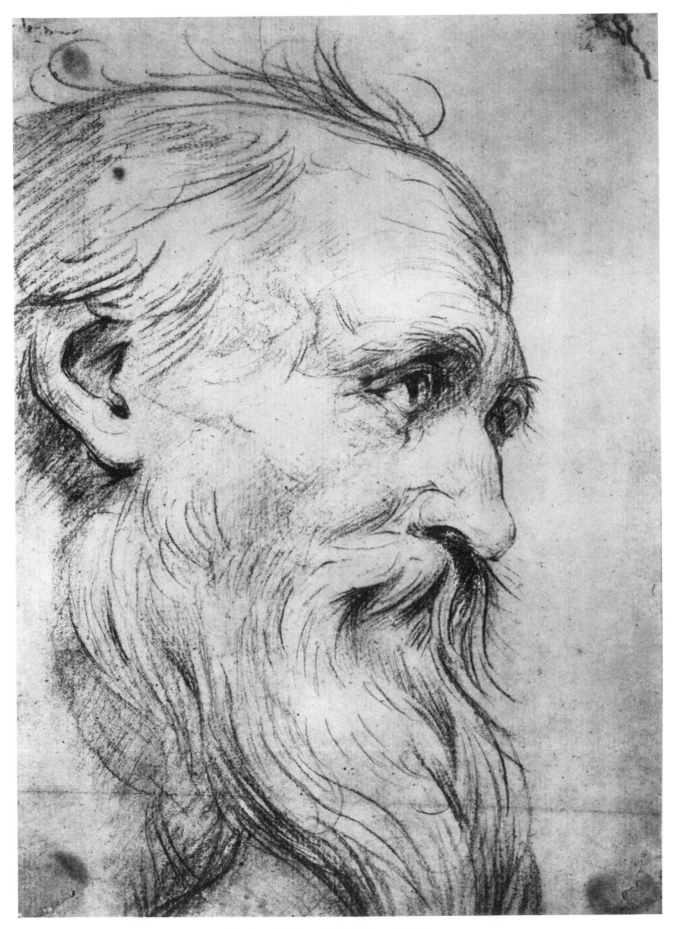

Benjamin West. *Head of an Old Man.*

Elie Nadelman. *Head and Neck*.

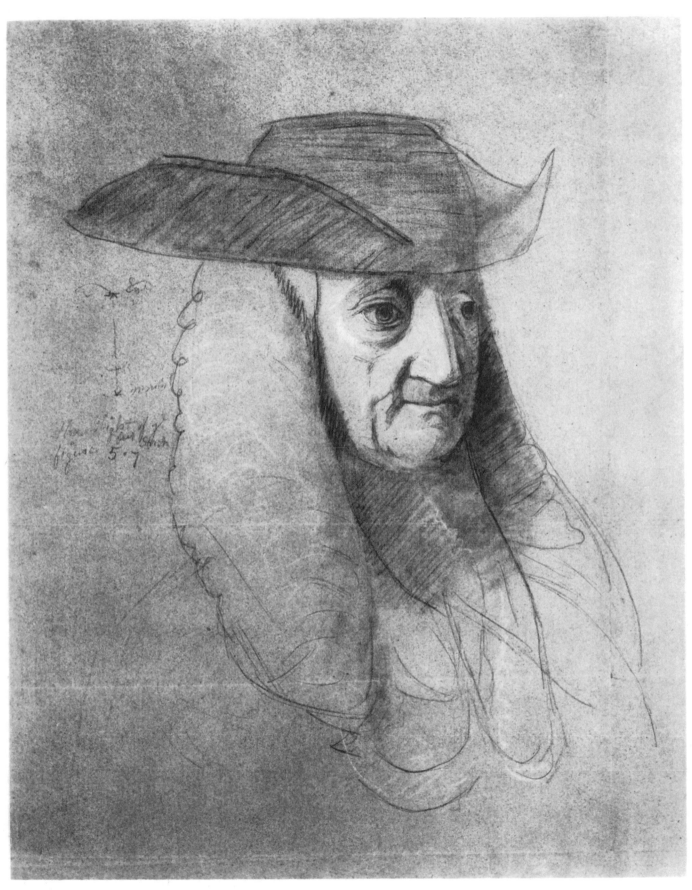

John Singleton Copley. *Head of the Earl of Bathurst, Lord Chancellor.*

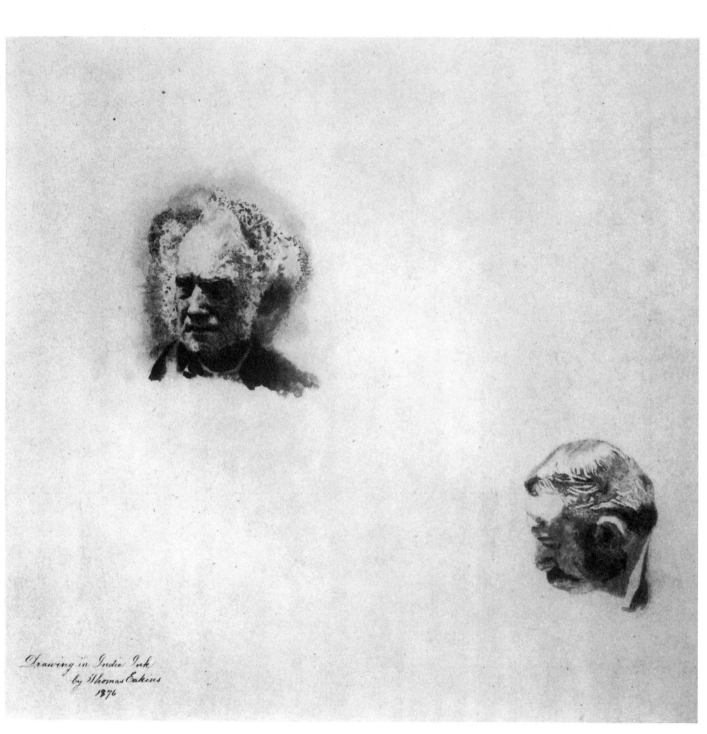

Drawing in India Ink
by Thomas Eakins
1876

Thomas Eakins. Study for *The Gross Clinic*.

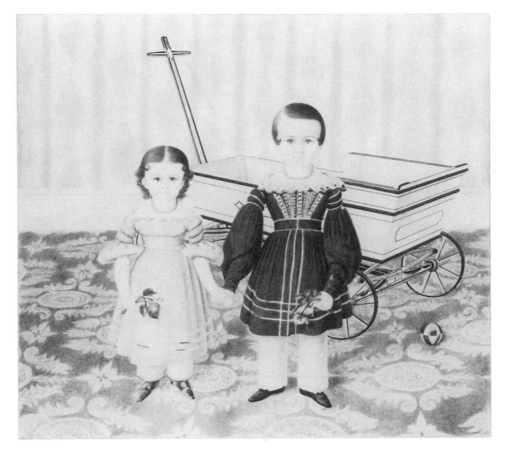

Henry Walton. *Frances and Charles Cowdrey.*

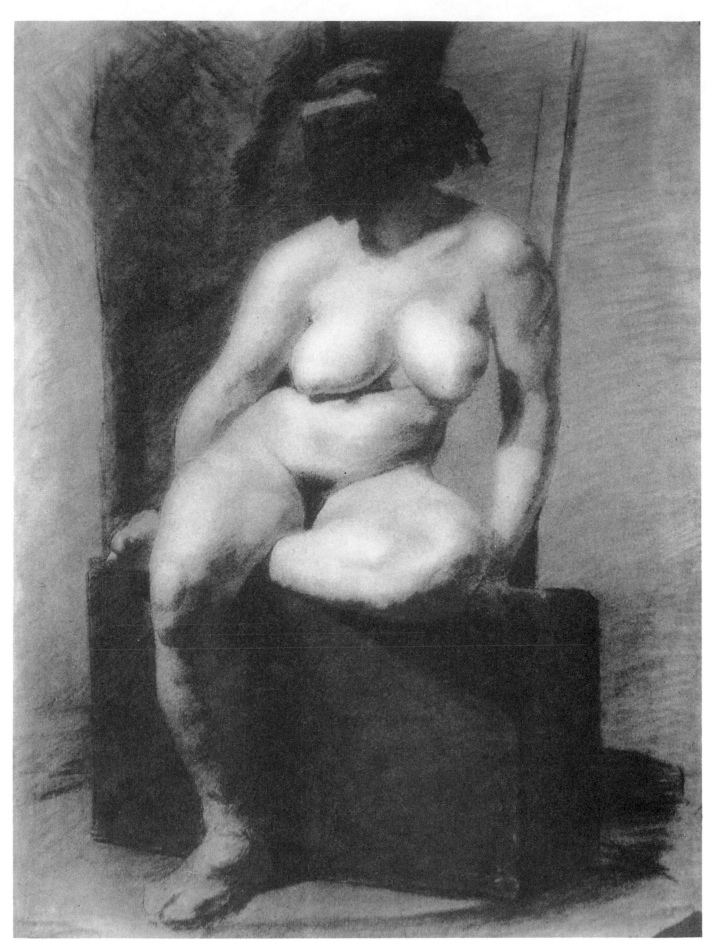

Thomas Eakins. *Nude Model.*

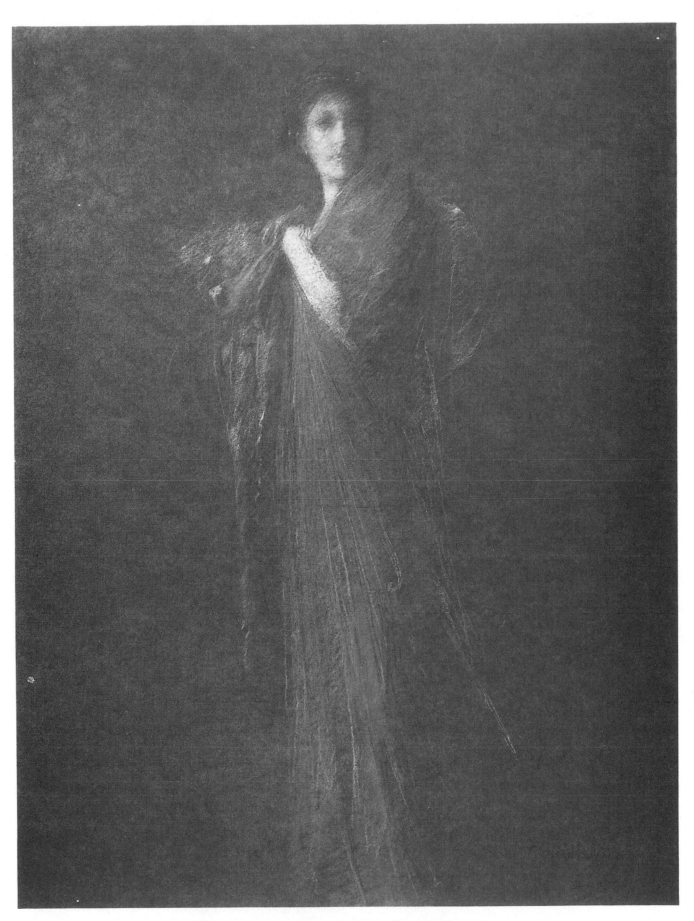

Thomas W. Dewing. *A Study (Lady with Flowers)*.

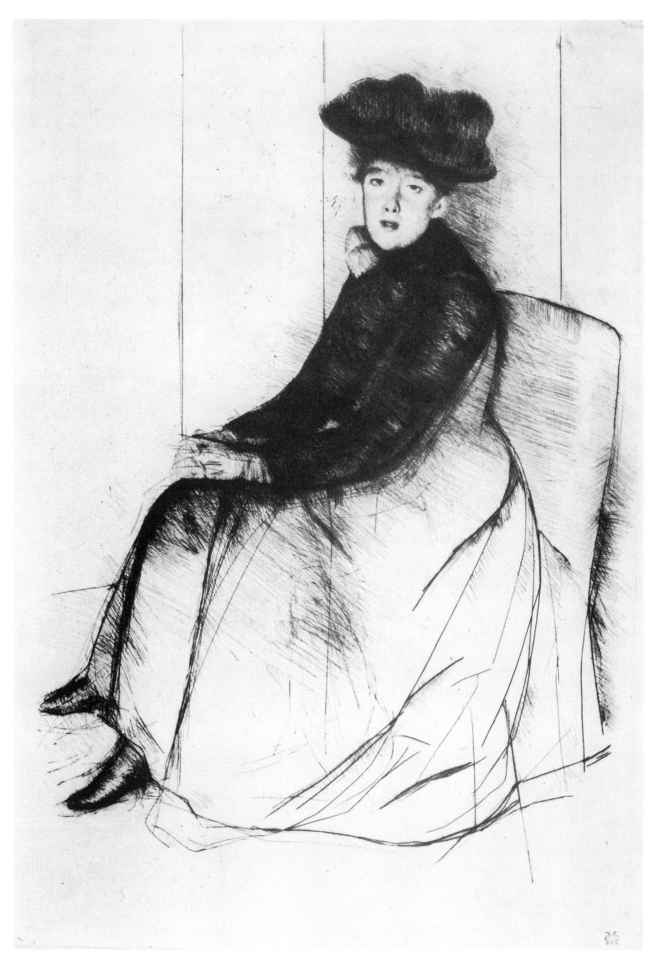

Mary Cassatt. *Reflection.*

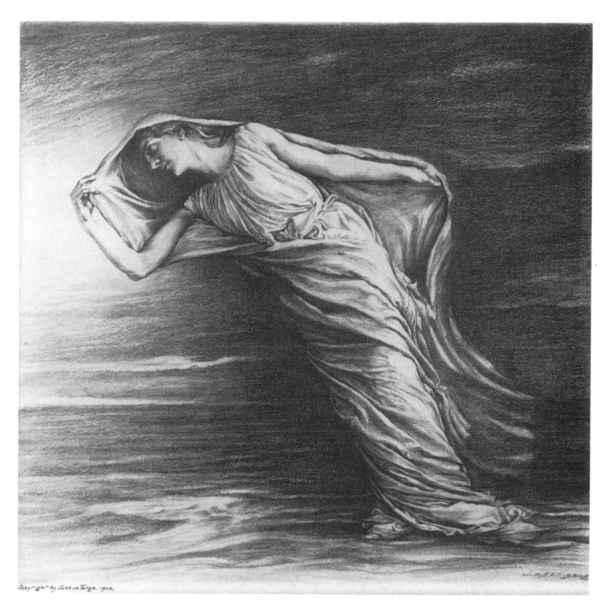

John La Farge. *Dawn Comes on the Edge of Night.*

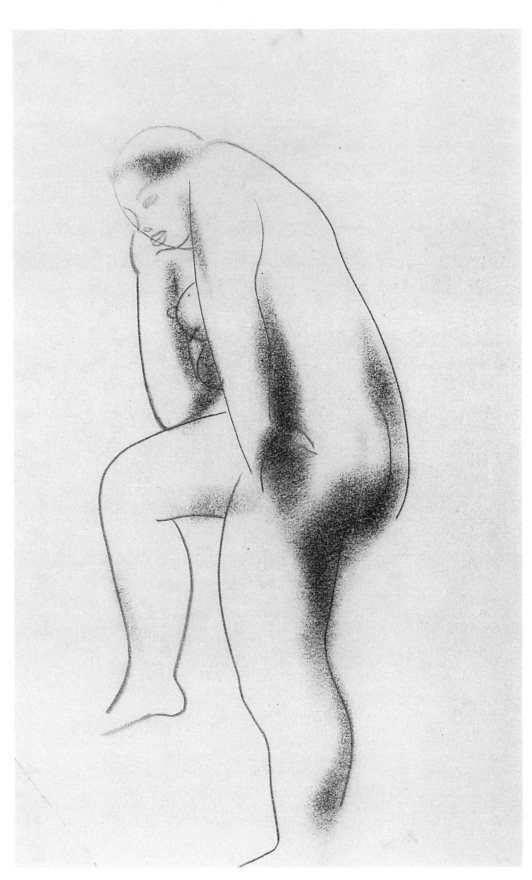

Isamu Noguchi. *Nude.*

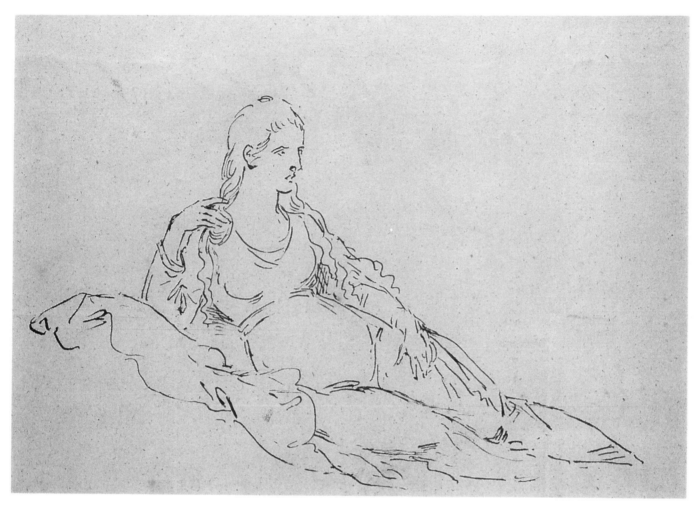

Benjamin West. *Una.*

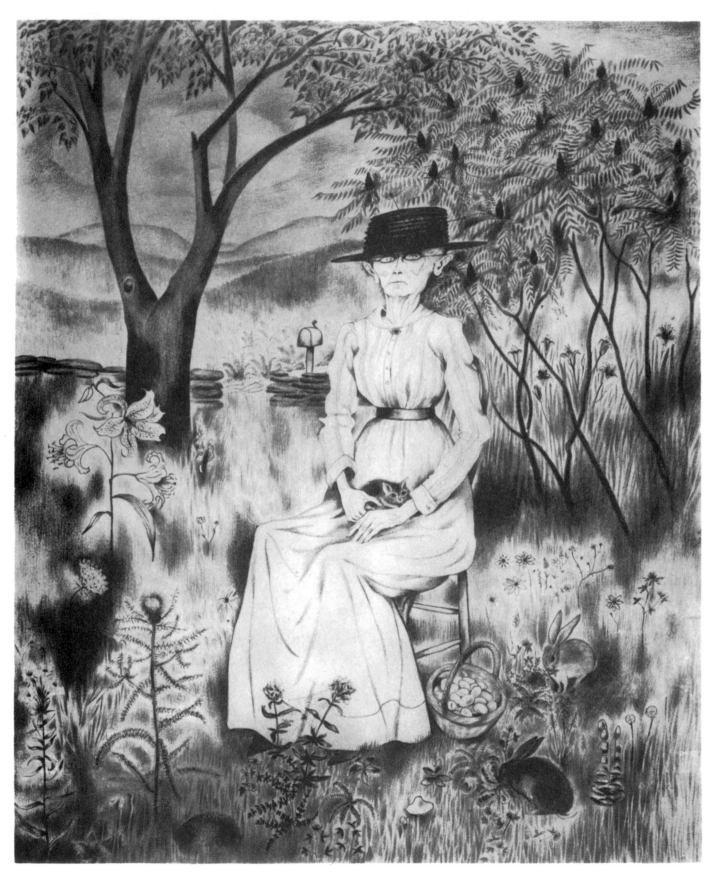

Peggy Bacon. *Blessed Damozel.*

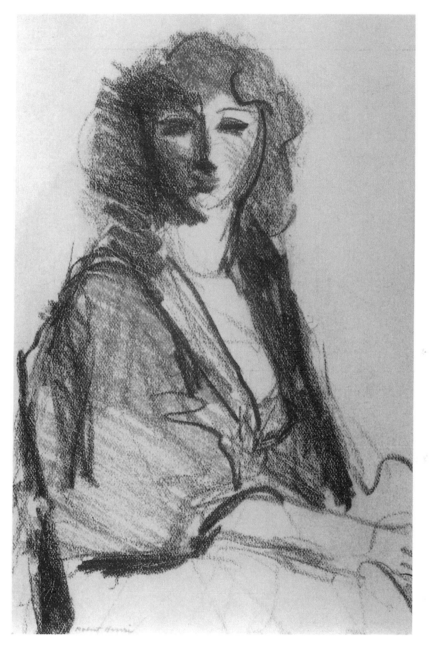

Robert Henri. *Portrait Head of a Woman.*

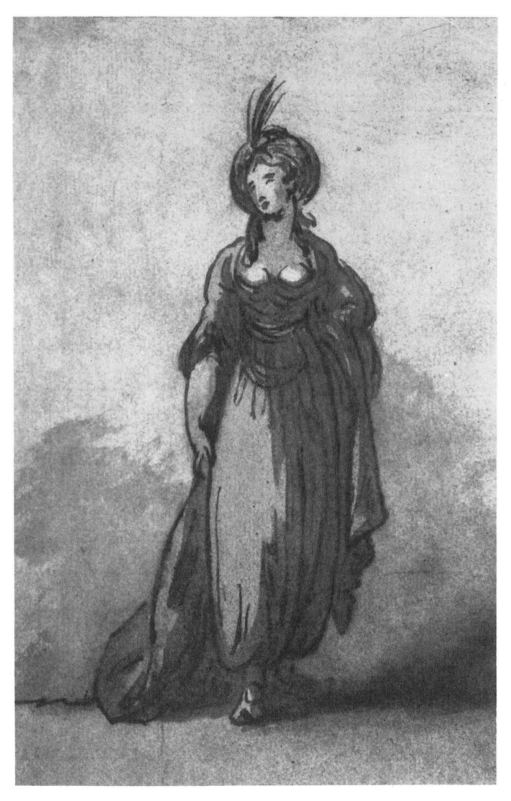

Mather Brown. *Woman.*

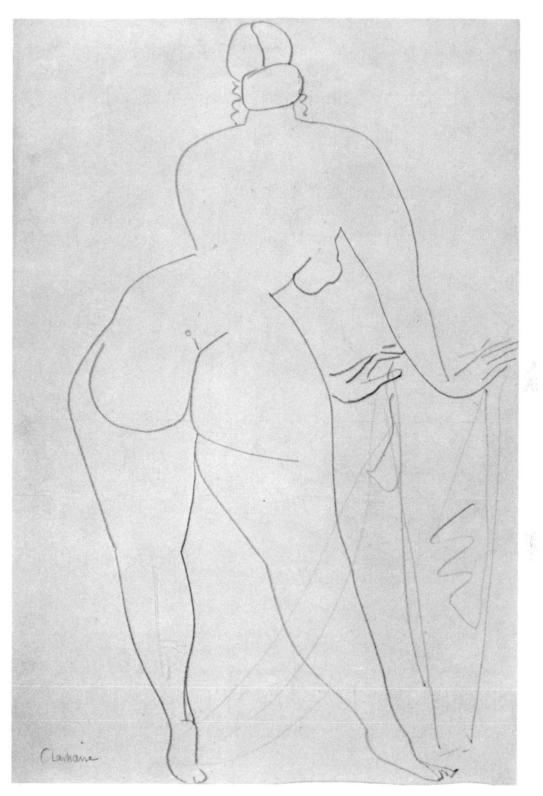

Gaston Lachaise. *Standing Nude.*

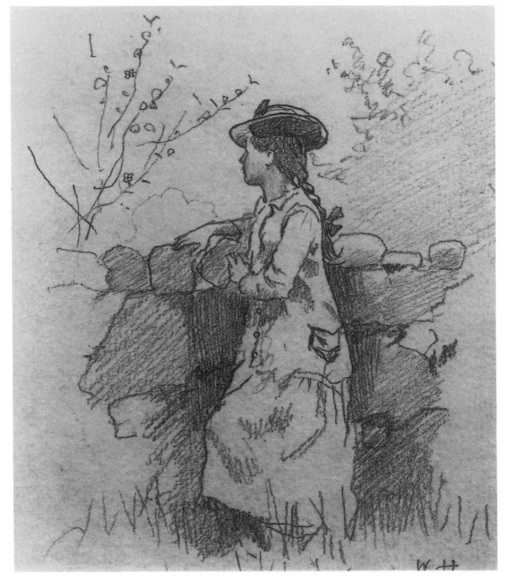

Winslow Homer. *Over the Garden Wall.*

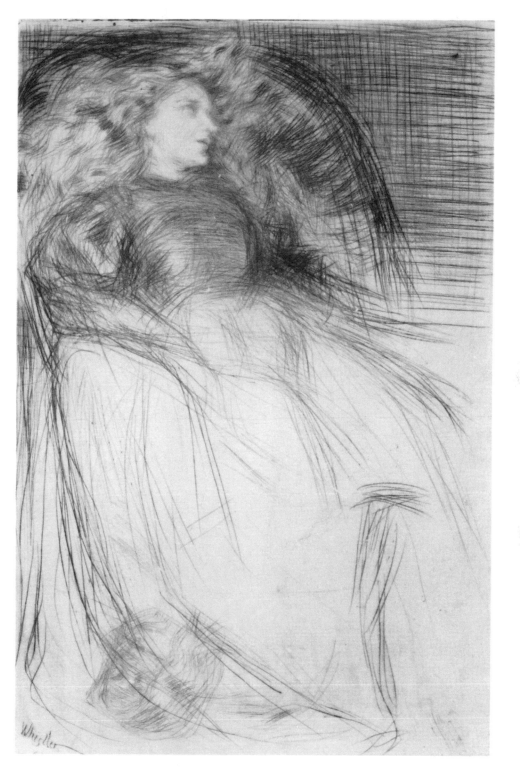

James Abbott McNeill Whistler. *Weary.*

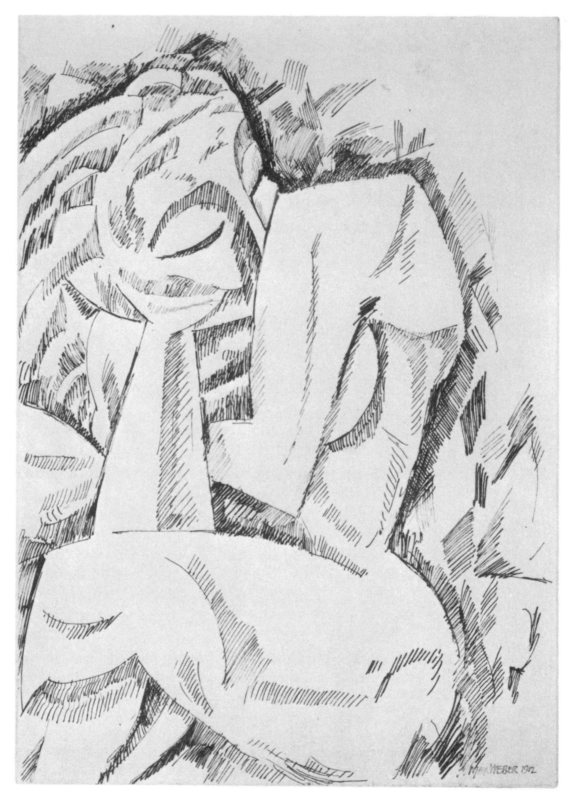

Max Weber. *Figure*.

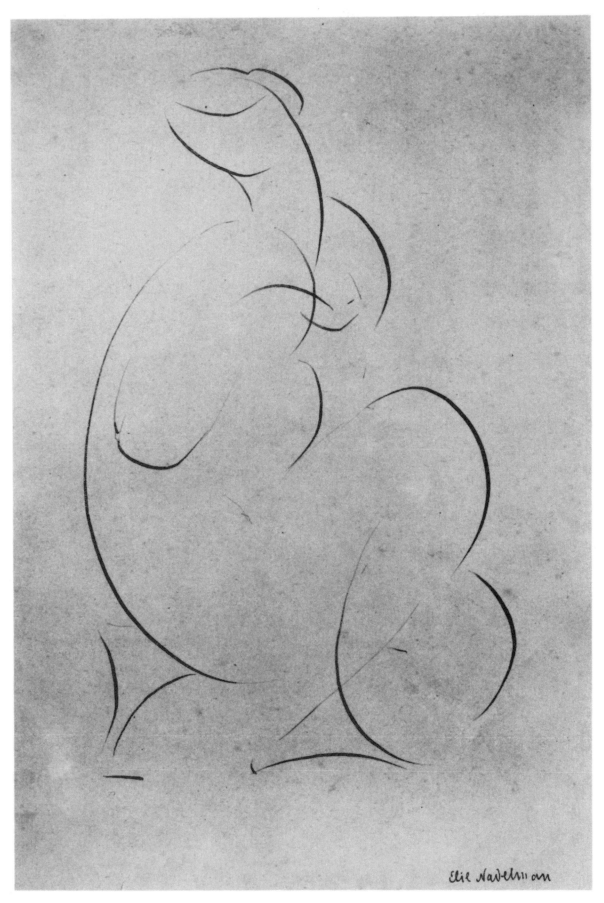

Elie Nadelman. *Seated Figure.*

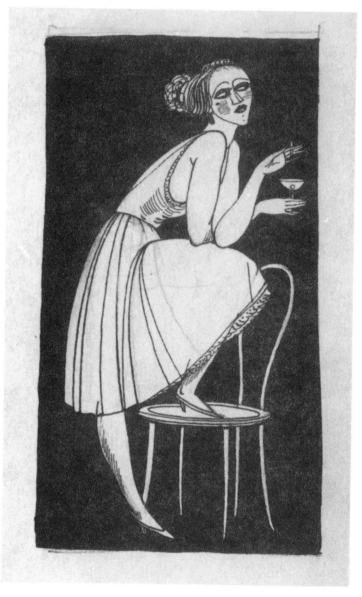

Rockwell Kent. *Woman with a Drink.*

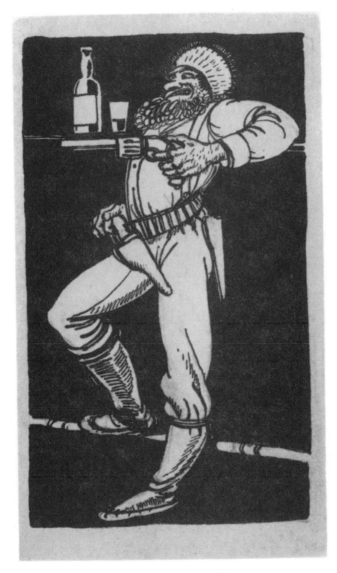

Rockwell Kent. *Gunfighter.*

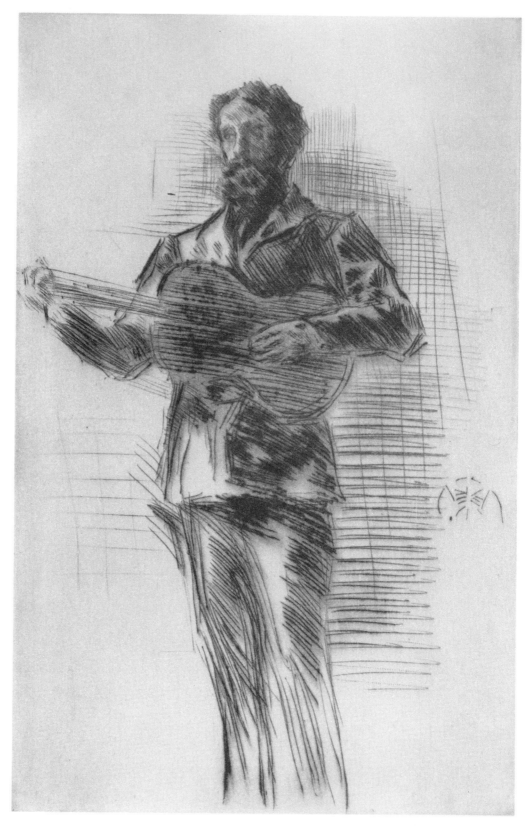

James Abbott McNeill Whistler. *The Guitar Player.*

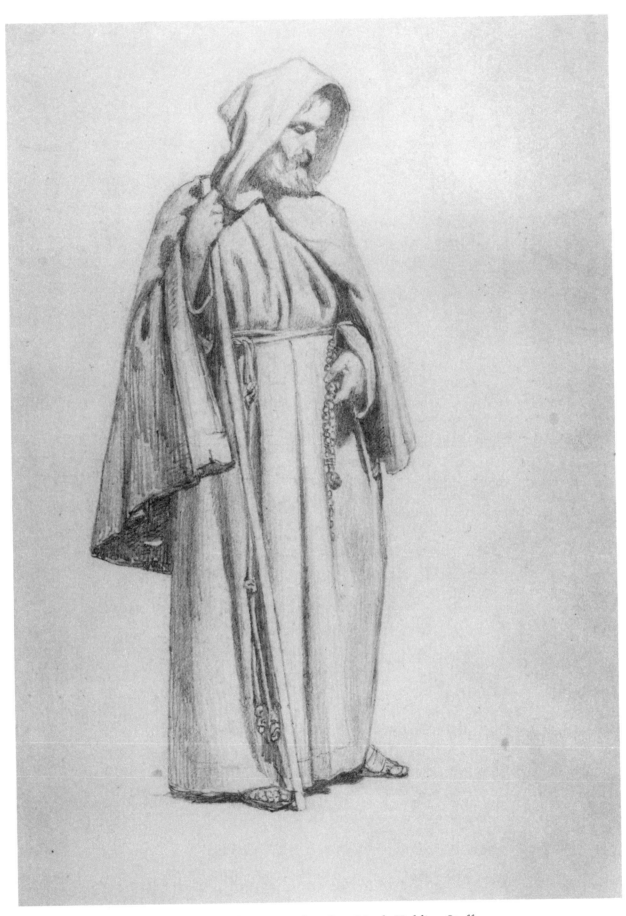

John Frederick Kensett. *Standing Monk Holding Staff.*

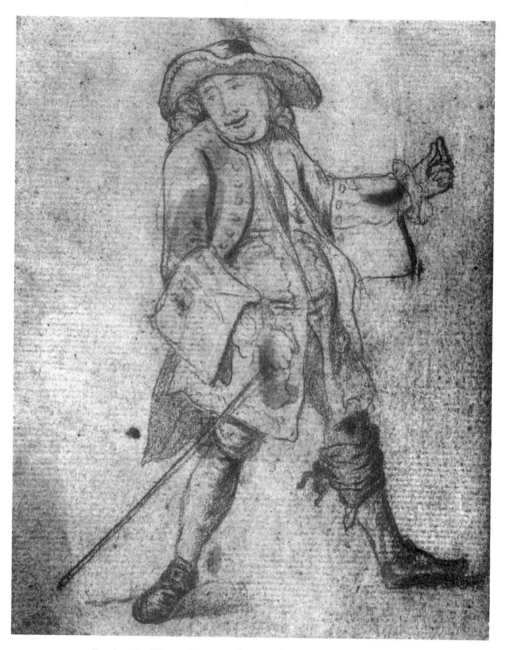

Benjamin West. *Man with a Walking Stick, Gesturing.*

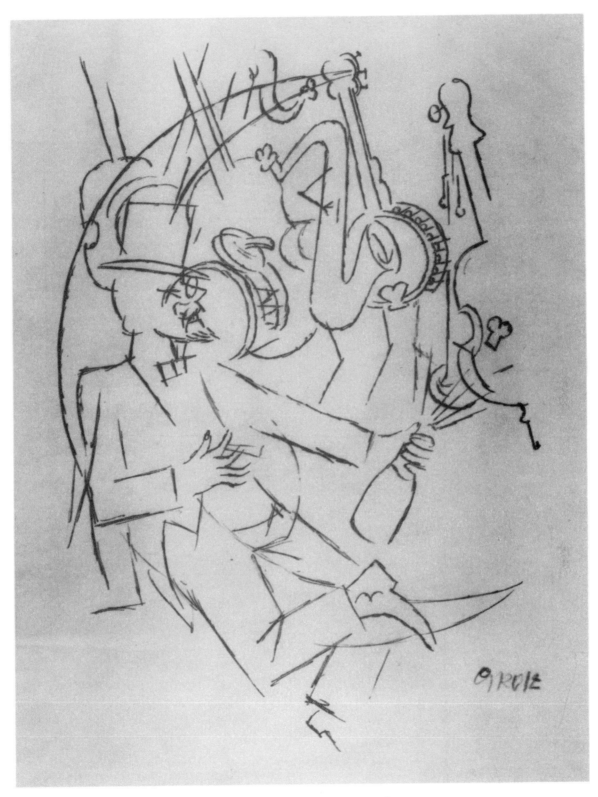

George Grosz. *Mann im Mond.*

Landscapes and the Country

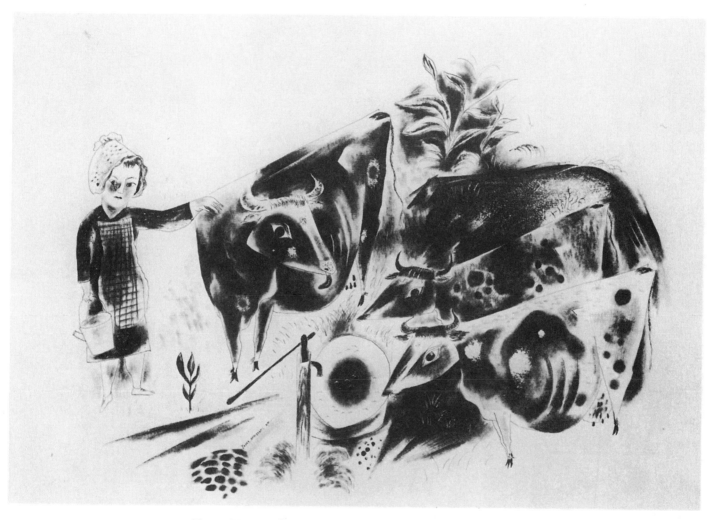

Yasuo Kuniyoshi. *Farmer's Daughter with Three Cows.*

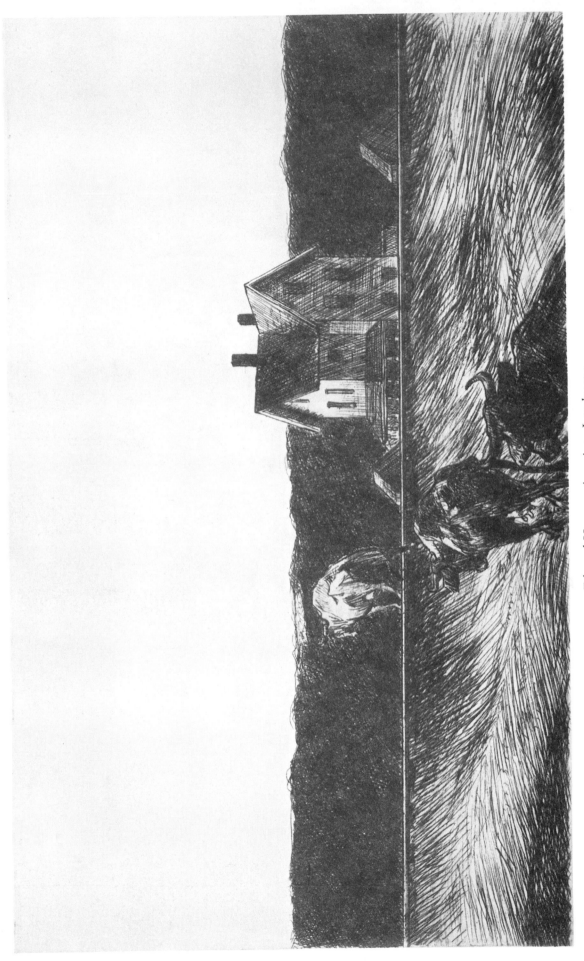

Edward Hopper. *American Landscape.*

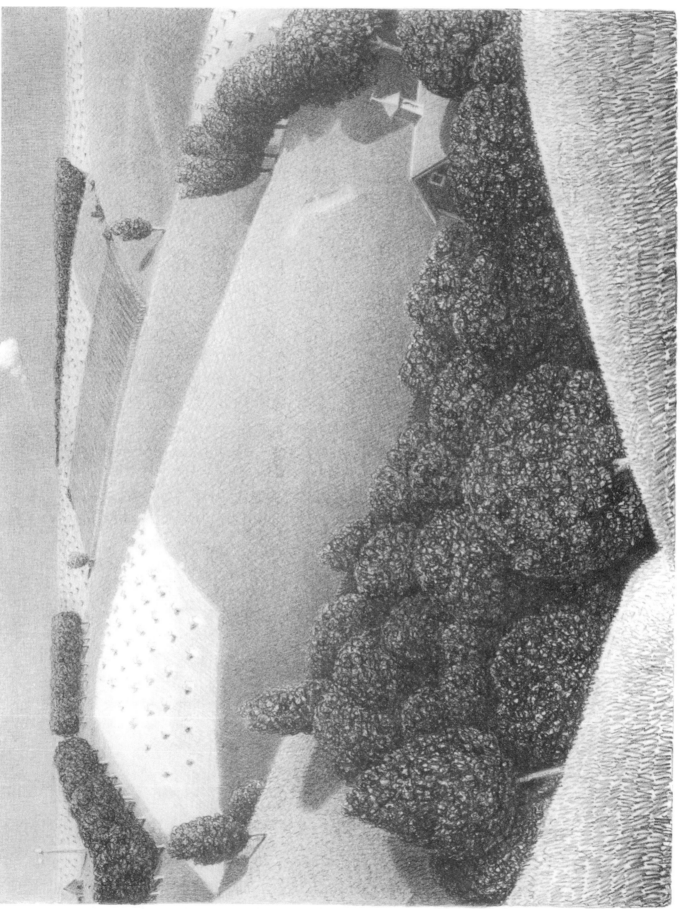

Grant Wood. *July Fifteenth.*

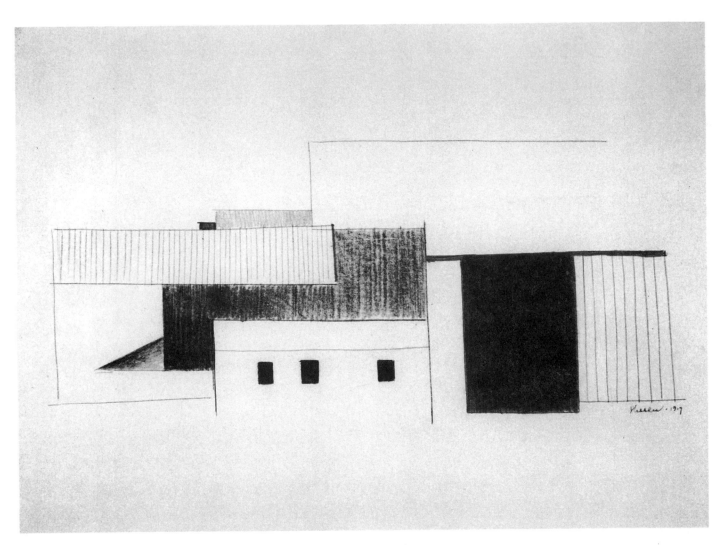

Charles Sheeler. *Barn Abstraction.*

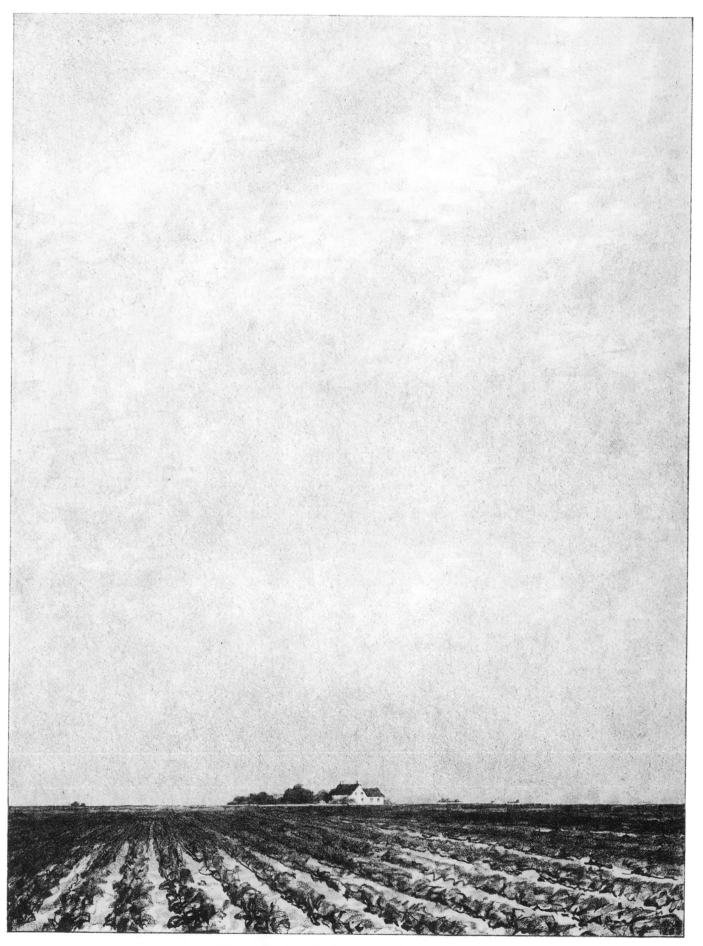

Albert Winslow Barker. *The Fertile Earth*.

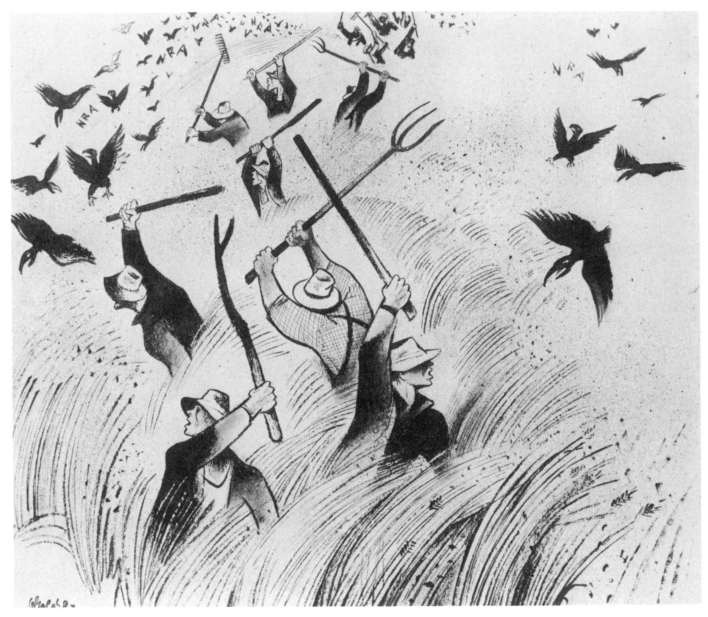

William Gropper. *Farmers' Revolt.*

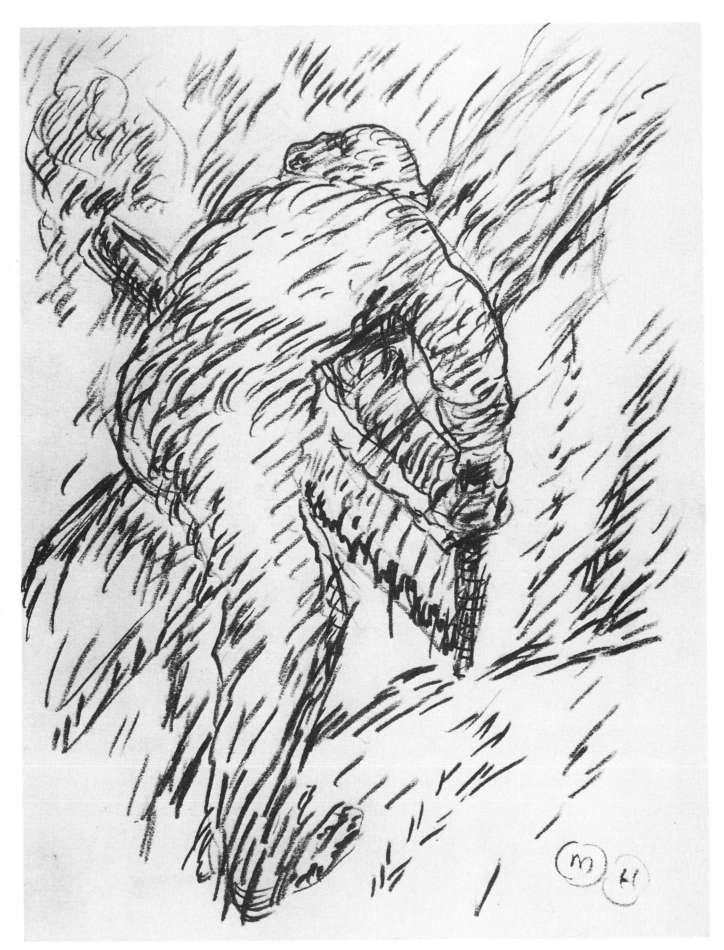

Marsden Hartley. *Sawing Wood.*

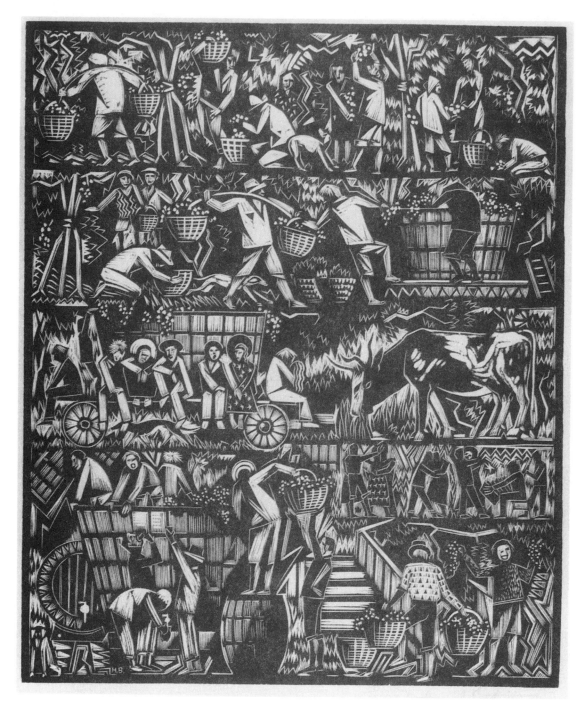

Harry Bertoia. *Grape Harvesters.*

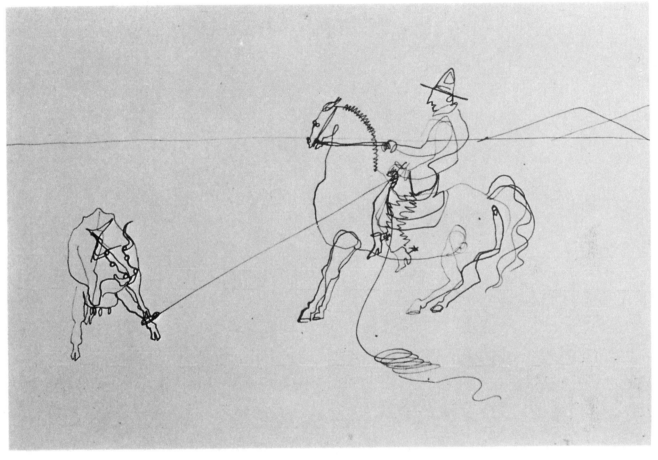

Alexander Calder. *Cowboy.*

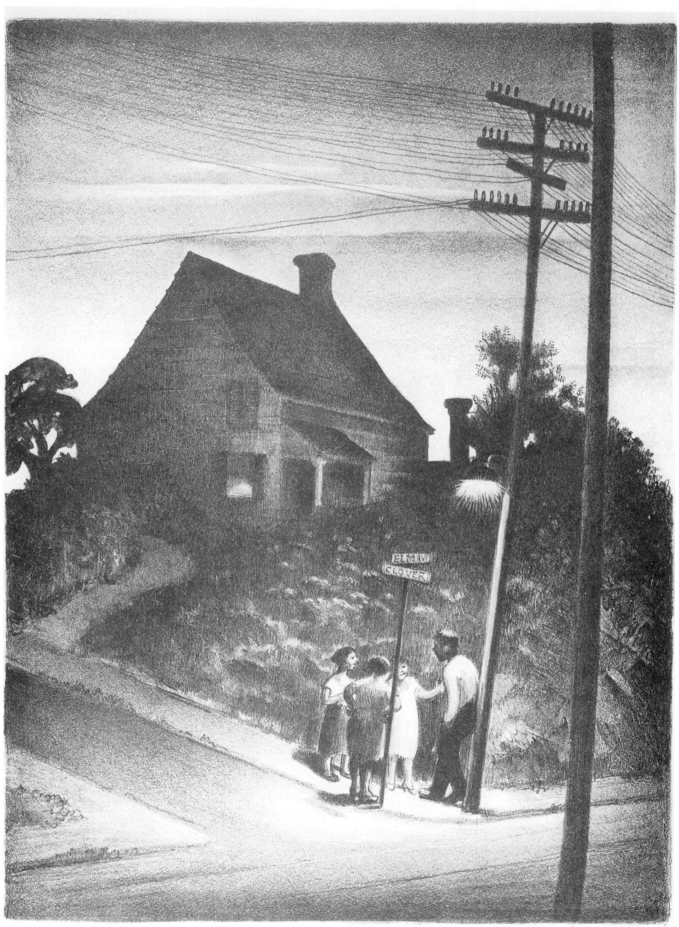

Mabel Dwight. *Dusk*.

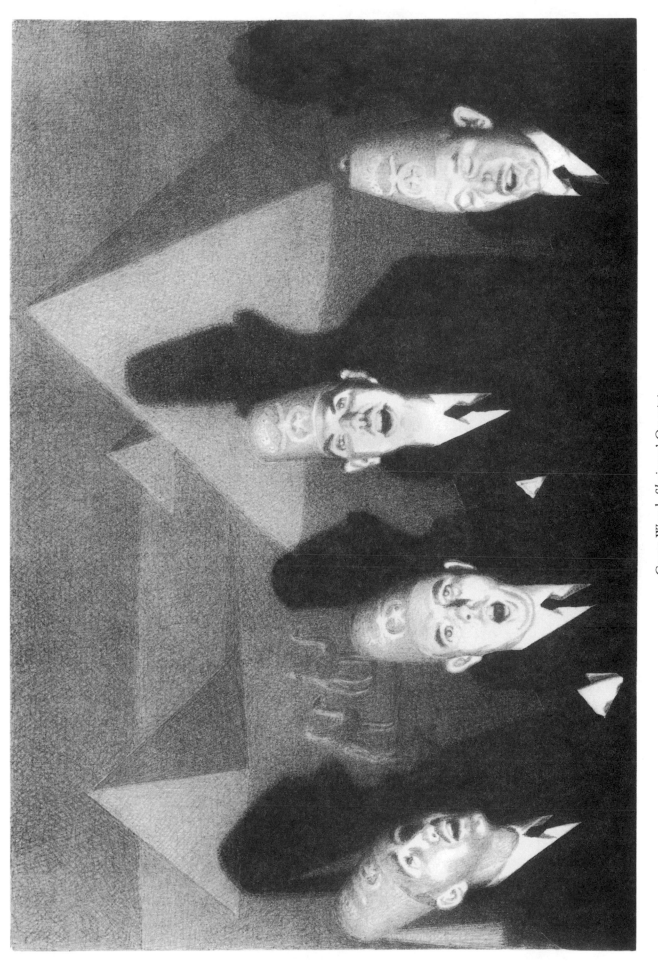

Grant Wood. *Shriners' Quartet.*

73

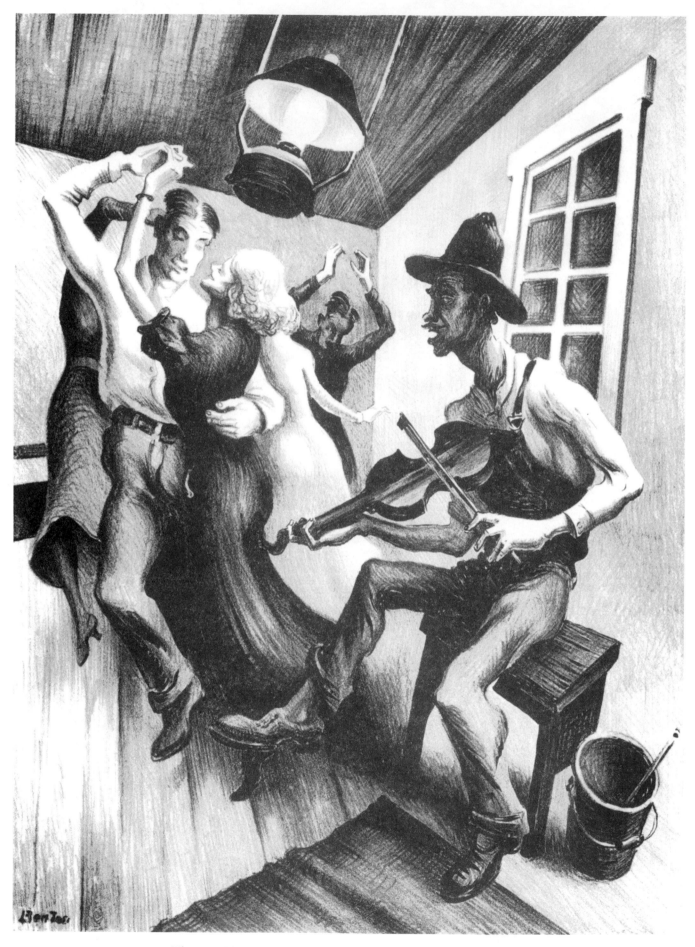

Thomas Hart Benton. *I Got a Gal on Sourwood Mountain.*

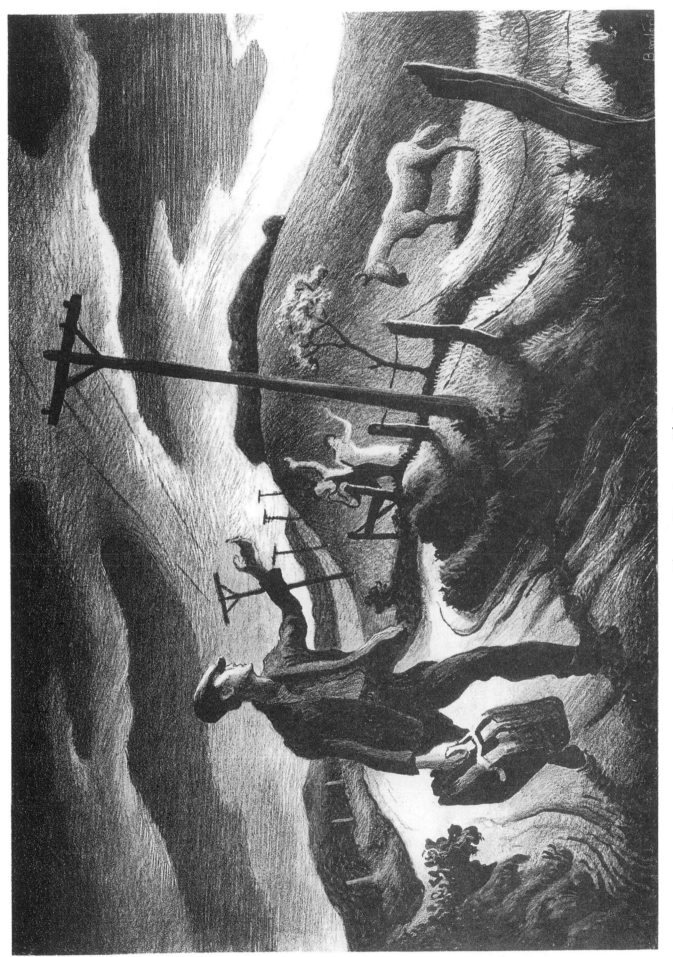

Thomas Hart Benton. *The Boy.*

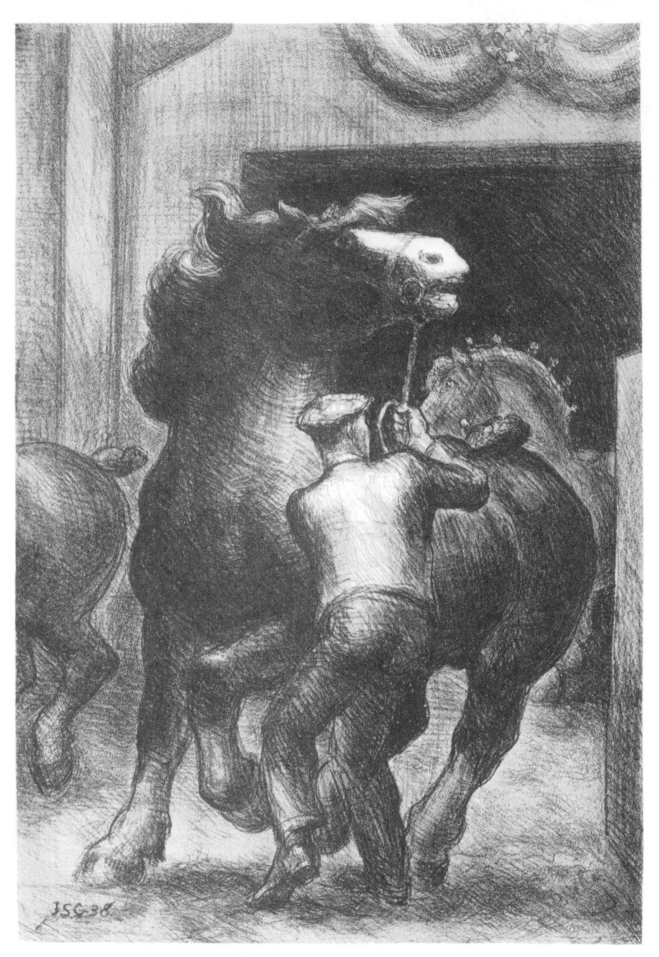

John Steuart Curry. *Prize Stallions.*

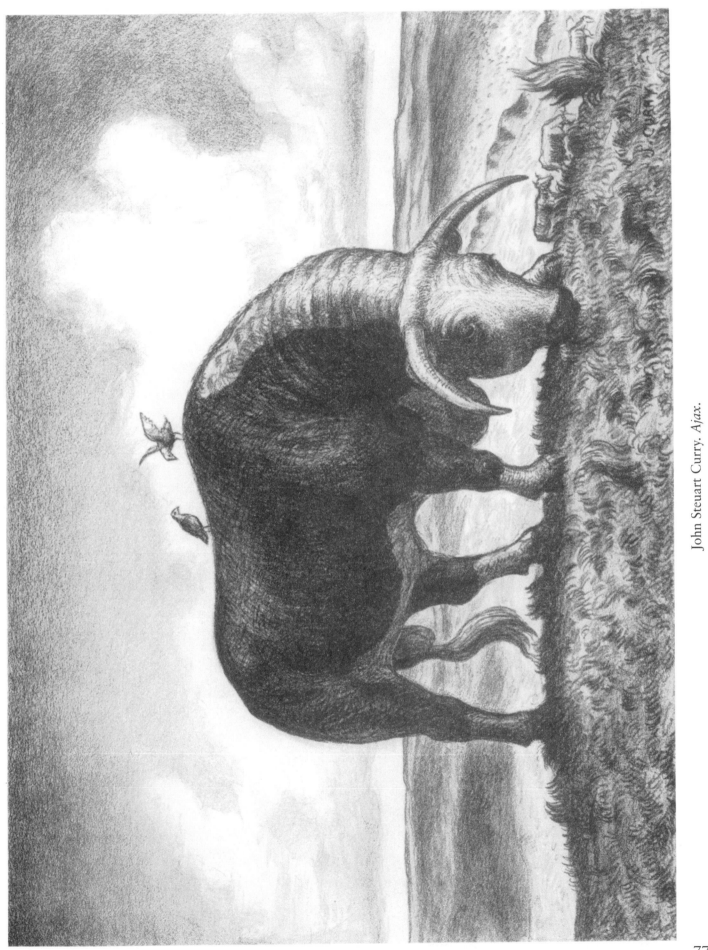

John Steuart Curry. *Ajax.*

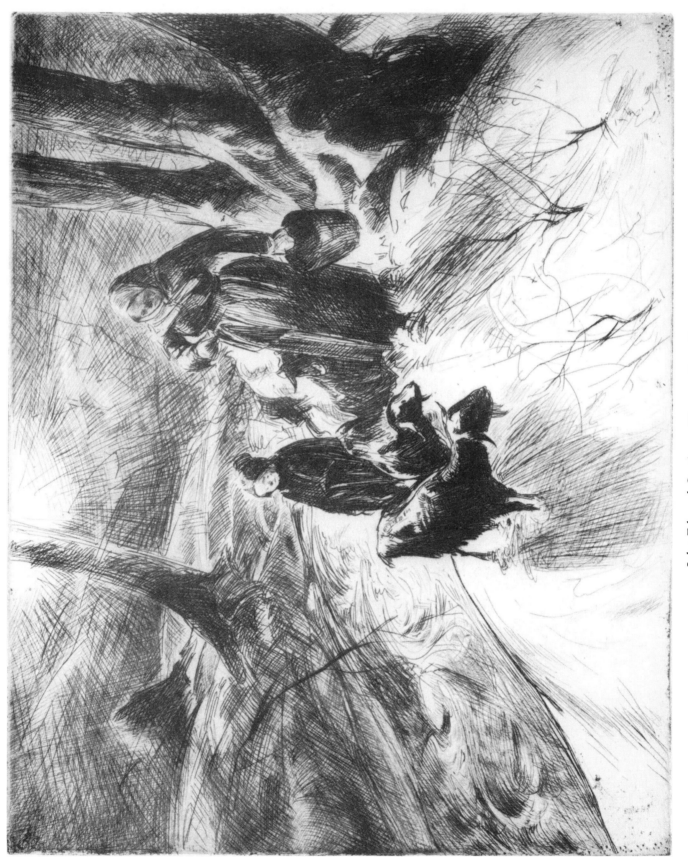

John Edward Costigan. *Woman, Boy, Goats.*

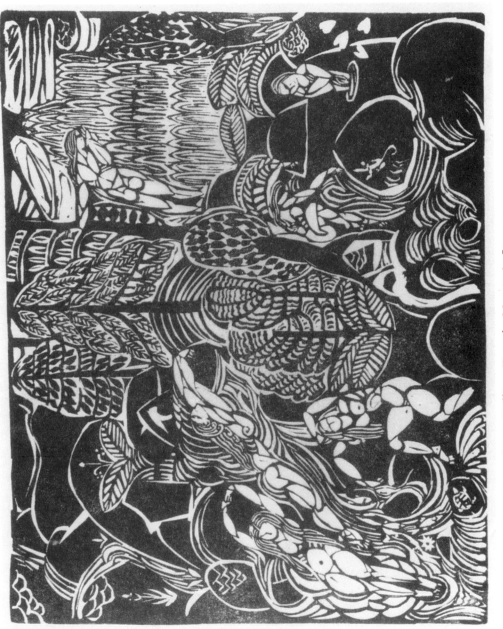

William Zorach. *Mountain Stream.*

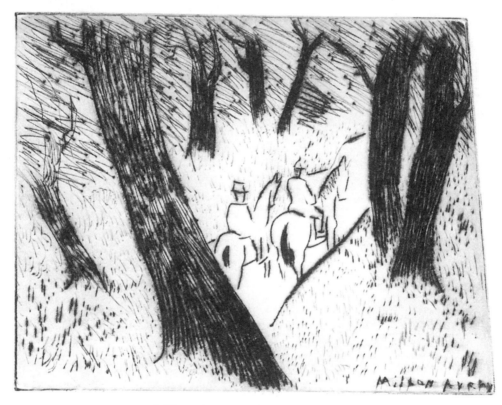

Milton Avery. *Riders in the Park*.

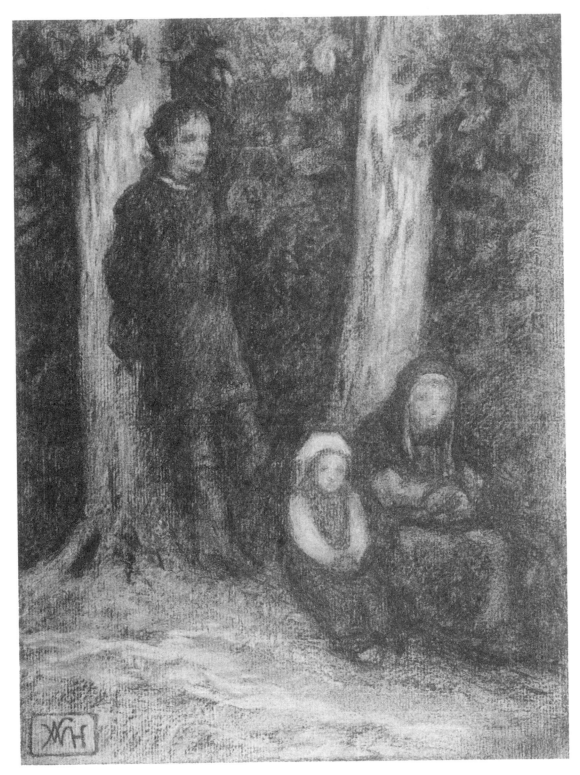

William Morris Hunt. Study for *"Three Generations."*

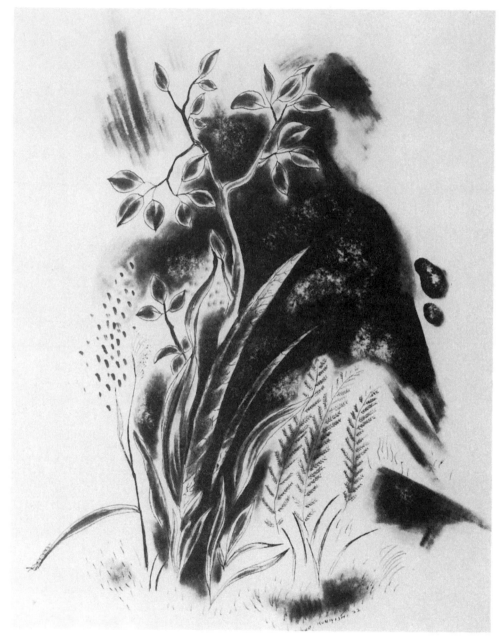

Yasuo Kuniyoshi. *Growing Plants.*

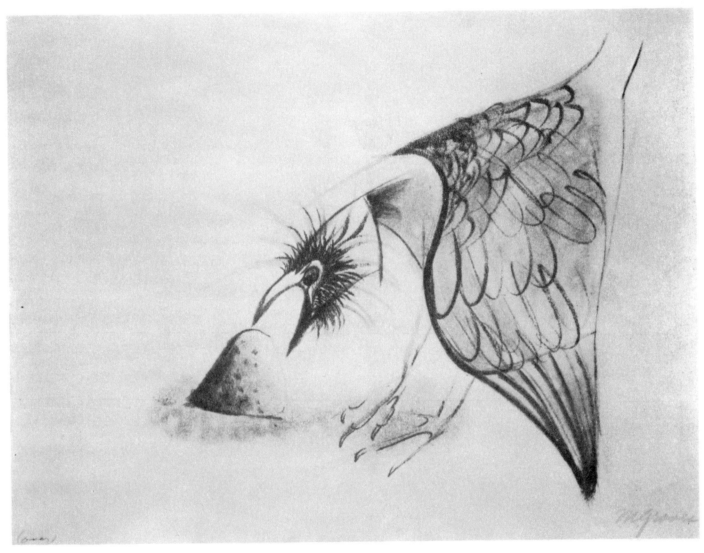

Morris Graves. *Bird Attacking Stone*.

Folk and Fantastic Art

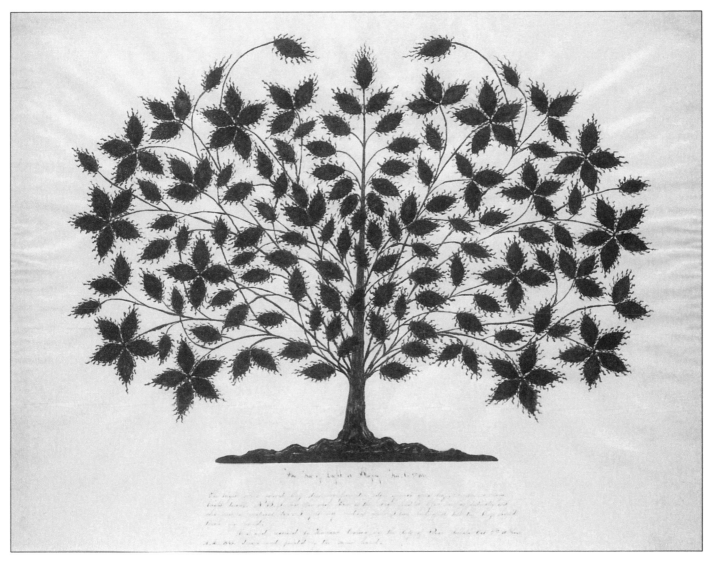

Hannah Cohoon (Shaker). *The Tree of Light or Blazing Tree.*

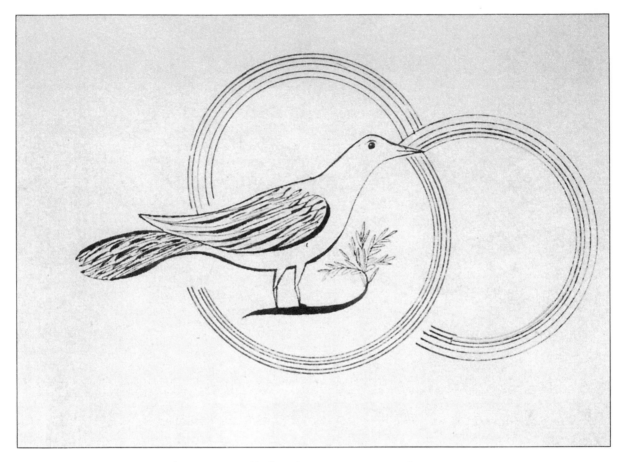

Anonymous (Shaker drawing). *Dove with Rings.*

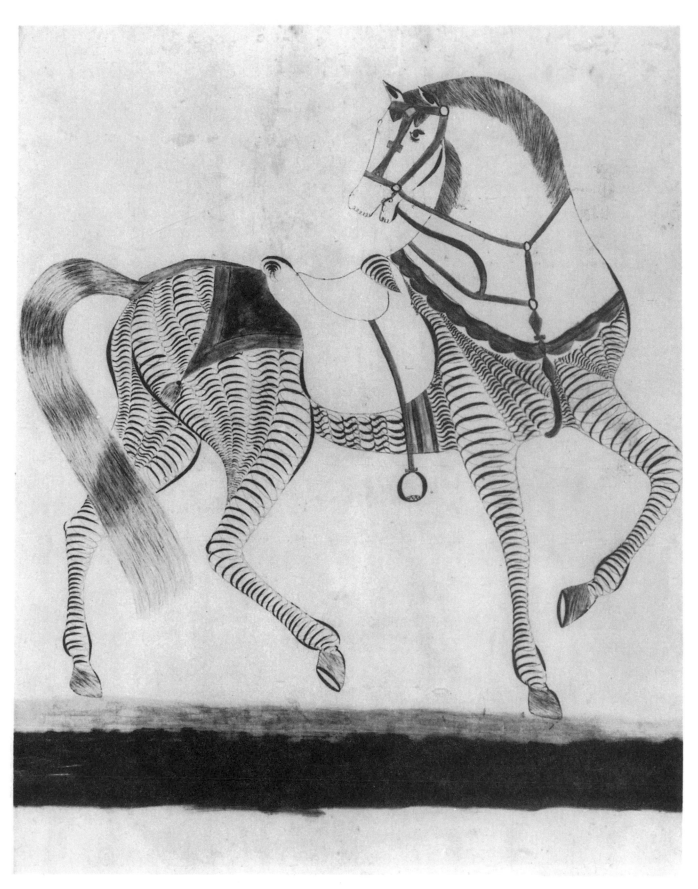

Anonymous (Pennsylvania German). *Horse.*

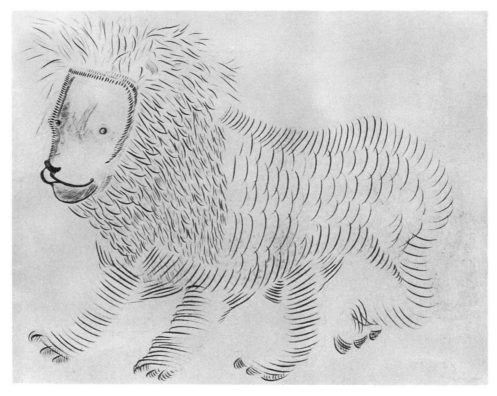

Anonymous. *Young Lion.*

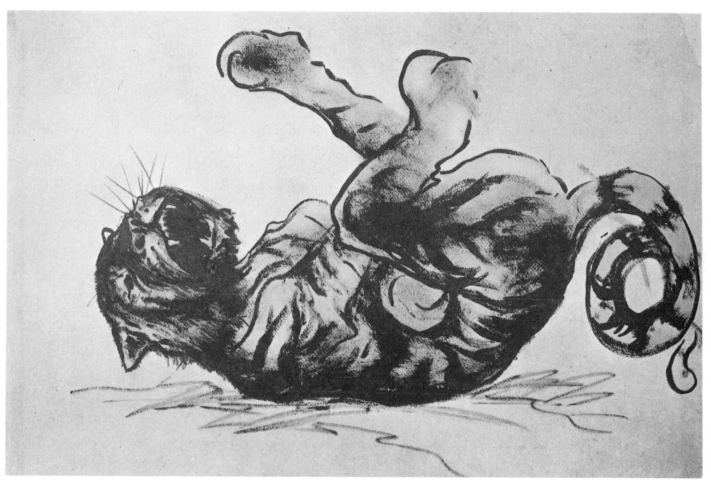

Thomas Nast. *Tammany Tiger.*

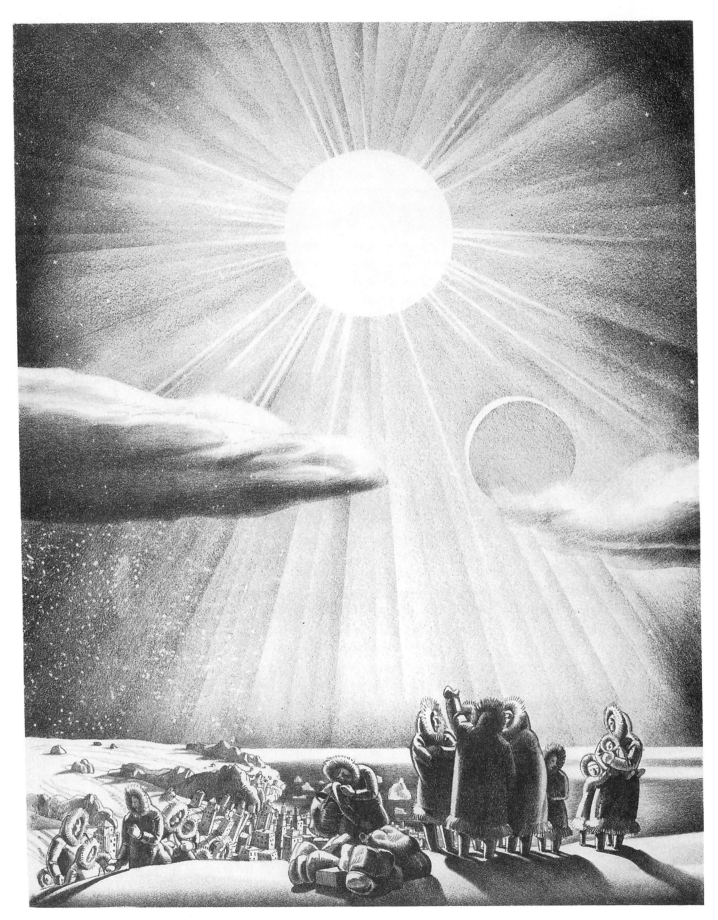

Rockwell Kent. *Solar Fade-Out.*

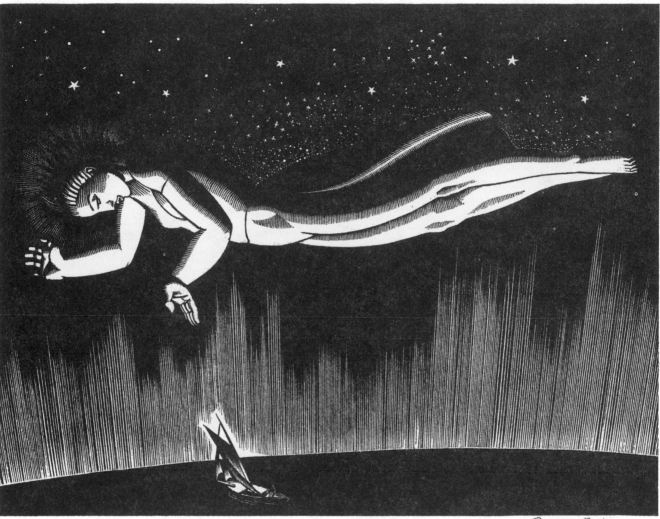

Rockwell Kent. *Godspeed.*

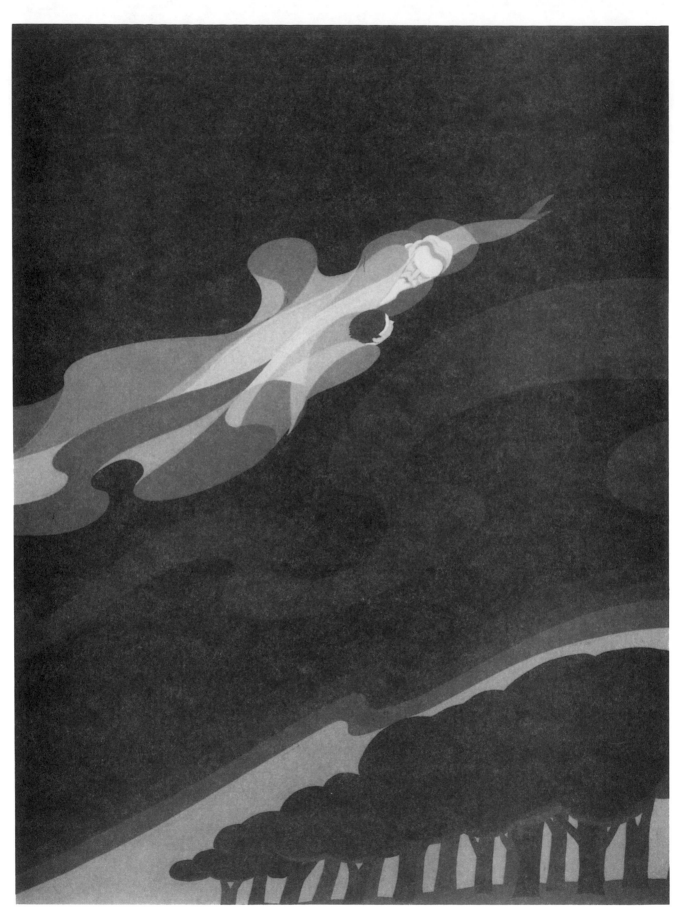

John Vassos. *The Bosom of His Father and His God.*

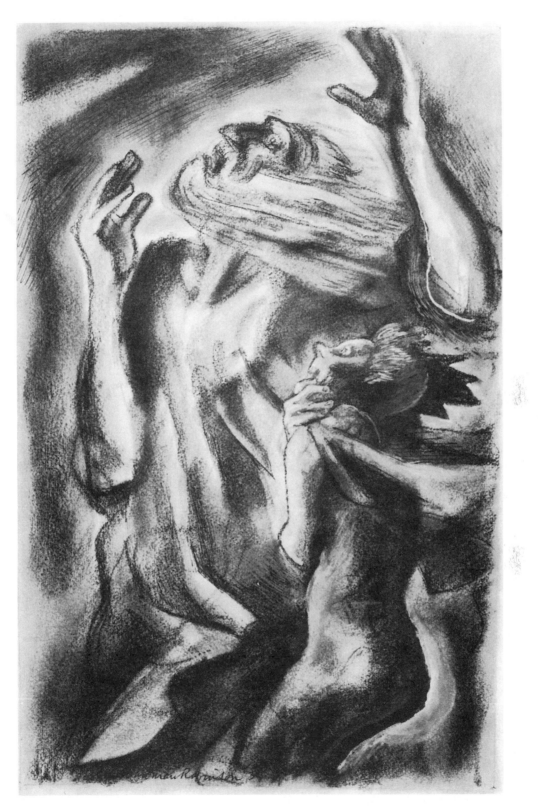

Boardman Robinson. *Lear and the Fool on the Heath*.

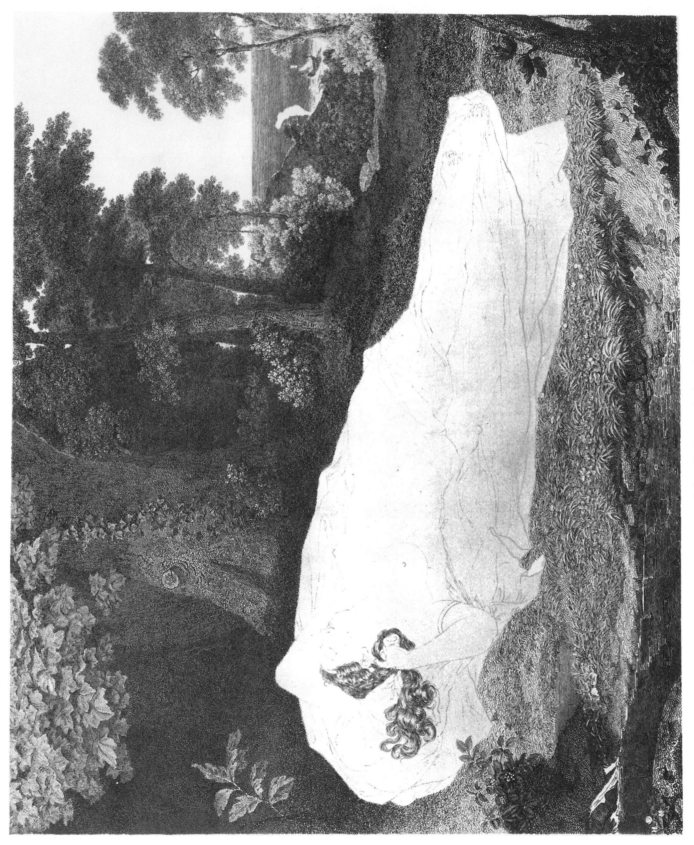

Asher B. Durand. *Ariadne.*

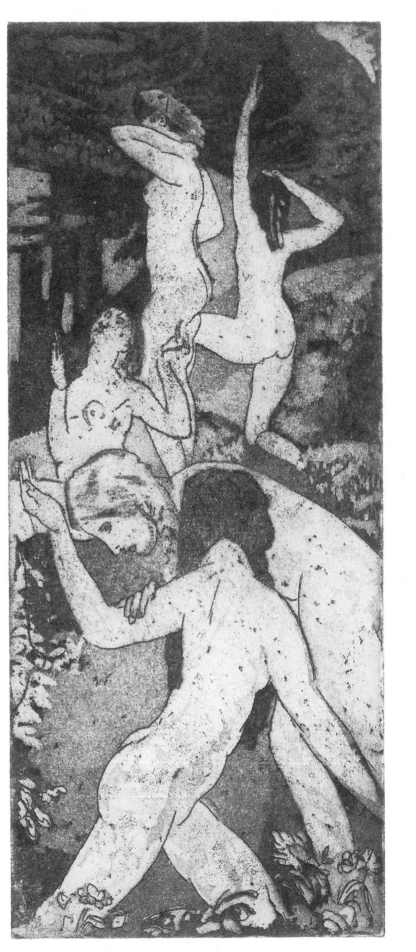

Arthur Bowen Davies. *Fountain of Youth.*

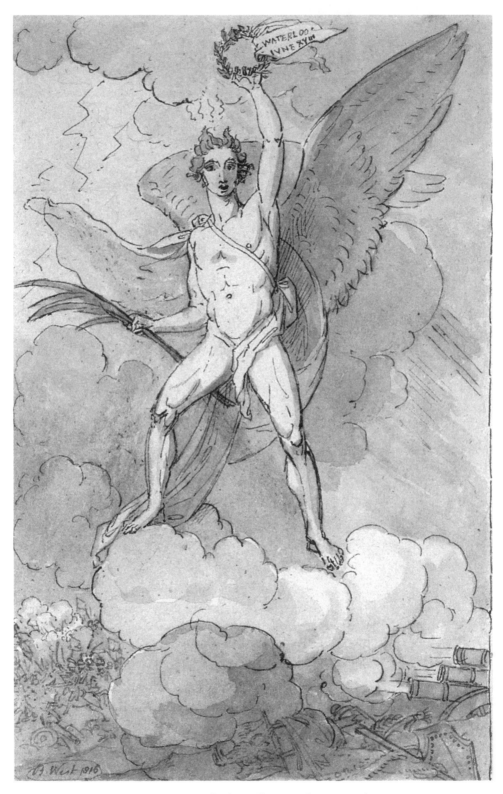

Benjamin West. Study for *Allegorical Figure of Victory
Celebrating the Battle of Waterloo.*

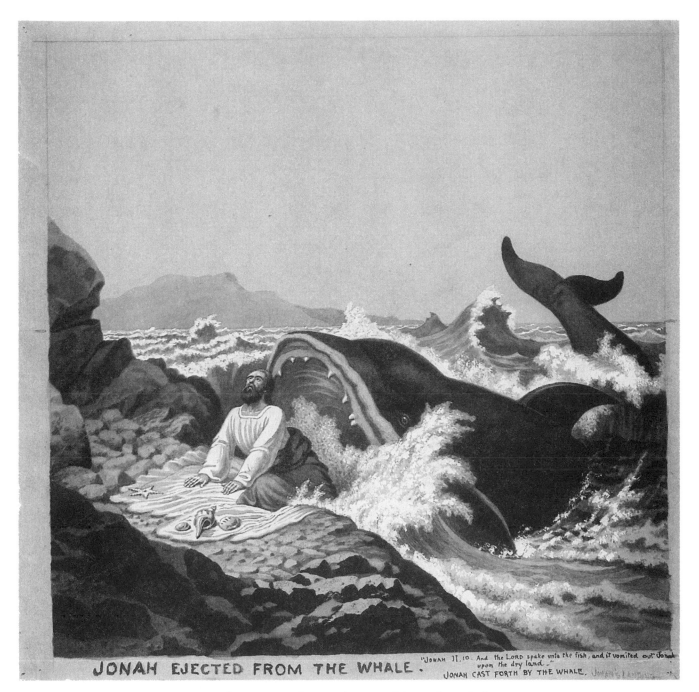

Joseph Boggs Beale. *Jonah Ejected from the Whale.*

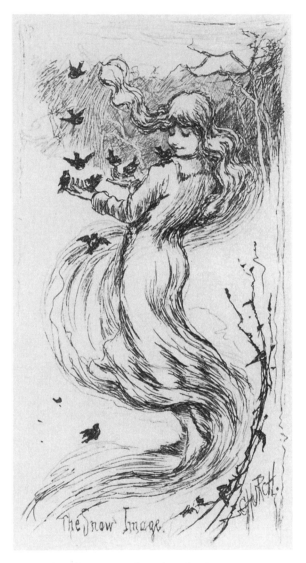

Frederick Stuart Church. *The Snow Image.*